Gardens in Perpetual Bloom
Botanical Illustration in Europe
and America 1600–1850

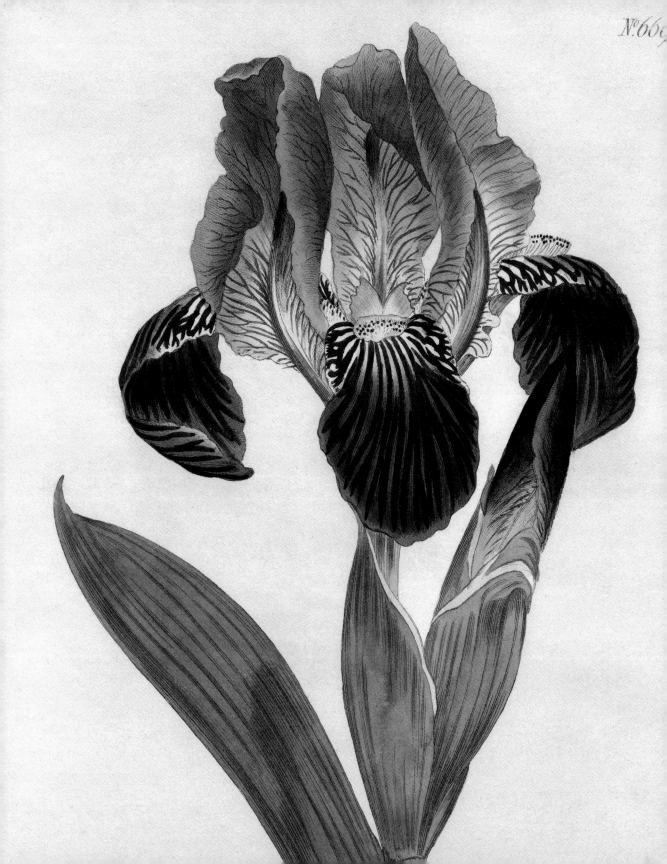

Gardens in Perpetual Bloom

Botanical Illustration in Europe and America 1600–1850

Nancy Keeler

MFA PUBLICATIONS

Museum of Fine Arts, Boston

MFA PUBLICATIONS
Museum of Fine Arts, Boston
465 Huntington Avenue
Boston, Massachusetts 02115
www.mfa.org/publications

This book was published in conjunction with the exhibition "Gardens in Perpetual Bloom: Botanical Illustration in Europe and America, 1600–1850," organized by the Museum of Fine Arts, Boston, and the Nagoya/Boston Museum of Fine Arts, from December 12, 2009, to April 4, 2010.

The Museum of Fine Arts, Boston, is a nonprofit institution devoted to the promotion and appreciation of the creative arts. The Museum endeavors to respect the copyrights of all authors and creators in a manner consistent with its nonprofit educational mission. If you feel any material has been included in this publication improperly, please contact the Department of Rights and Licensing at 617 267 9300, or by mail at the above address.

While the objects in this publication necessarily represent only a small portion of the MFA's holdings, the Museum is proud to be a leader within the American museum community in sharing the objects in its collection via its Web site. Currently, information about more than 340,000 objects is available to the public worldwide. To learn more about the MFA's collections, including provenance, publication, and exhibition history, kindly visit www.mfa.org/collections.

For a complete listing of MFA publications, please contact the publisher at the above address, or call 617 369 3438.

All illustrations in this book were photographed by Jared Medeiros and the Imaging Studios, Museum of Fine Arts, Boston, except where otherwise noted.

Edited by Sarah McGaughey Tremblay
Copyedited and proofread by Sarah Kane
Designed by Misha Anikst
Produced by GILES, an imprint of D Giles Limited, London

Available through D.A.P. / Distributed Art Publishers
155 Sixth Avenue, 2nd floor
New York, New York 10013
Tel.: 212 627 1999 · Fax: 212 627 9484

FIRST EDITION
Printed and bound in China
This book was printed on acid-free paper.

Contents

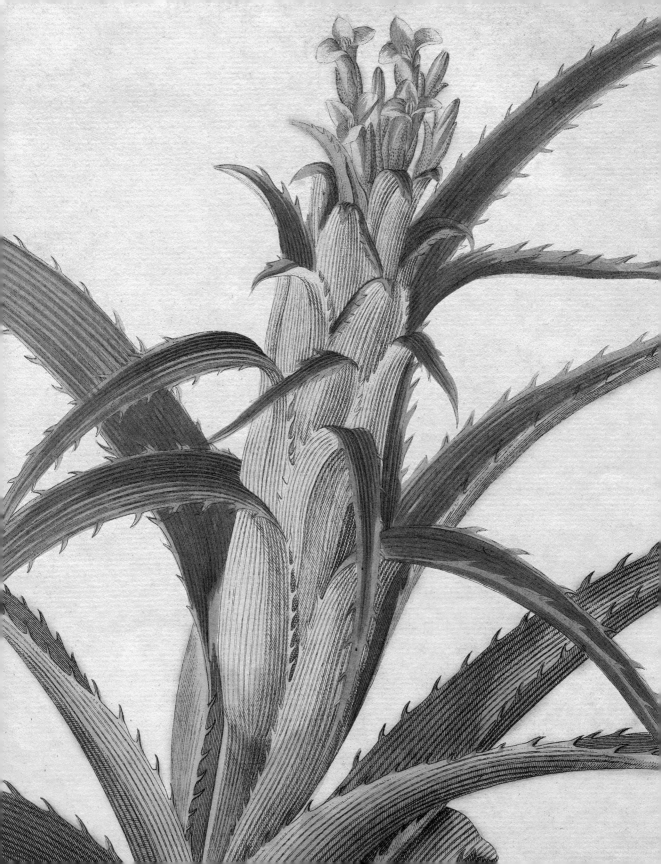

Directors' Forewords

It must have been the beauty of creation that opened the human eye to art for the first time. Plants in particular have attracted our gaze in every region and civilization from ancient times to the present. Whether in a principal or supporting role, they are often an important part of the pictures we conceive. Such basic interest in the beauty of plants can certainly be seen in Asian art, including the arts of Japan. We Japanese are especially drawn to flowers, which to us can symbolize alternate existences in paradise.

Botanical art as a genre of the Western tradition was born out of the human passion to know the mechanics of beauty in scientific detail. That same desire led Leonardo da Vinci to dissect a human body. Originally the pleasure of kings, aristocrats, and others with the means to cultivate plants for the sake of their beauty, botanical art was able to reach a broader audience after the nineteenth century, when gardening became more affordable to regular citizens, and technical progress was made in engraving and printmaking.

With a long history of collecting botanical art, the Museum of Fine Arts, Boston, has holdings in this area that are rich in both quality and quantity. Its staff has selected over one hundred works originally published in Europe and America from the seventeenth to mid-nineteenth centuries, so that we, who love the four seasons of nature, may have the opportunity to know their charm. I present my deep gratitude to the MFA for giving us this wonderful bouquet born from a marriage of human sensibility and intelligence.

Shunkichi Baba
Director, Nagoya/Boston Museum of Fine Arts

It is a pleasure for the Museum of Fine Arts, Boston, to collaborate with the Nagoya/Boston Museum of Fine Arts on *Gardens in Perpetual Bloom: Botanical Illustration in Europe and America, 1600–1850.* The Museum is fortunate to have a noteworthy collection of prints from the golden age of this exceptional genre in which the work of talented artists endows informative scientific records with aesthetic presence. One hundred thirteen prints and one watercolor make up the exhibition. The prints were selected from thirty-five of the greatest books in the history of botanical illustration and represent all the important developments in printmaking.

The collection is built on a weighty core, the Elita R. Dike Collection, which came to us as a bequest in 1969 from George P. Dike. Other significant gifts through the years have enhanced this collection. In 1988, Mrs. Sigmund Katz gave a group of botanical prints and watercolors related to the decoration of porcelain, part of a bequest of fine porcelain ceramics that also included several books of outstanding quality. Other important gifts have come from the Boston print seller Charles D. Childs, noted animal artist Katharine Lane Weems, and Stephen Borkowski of Provincetown. We continue to add strategically to the collection, as with our recent purchase of Gerard van Spaendonck's *Double Hyacinth* from his masterly work, *Fleurs Dessinées d'après Nature.* We are happy to be able to share the pleasure of viewing these superb works with our friends in Japan.

Malcolm Rogers
Ann and Graham Gund Director
Museum of Fine Arts, Boston

Gardens in Perpetual Bloom: Botanical Illustration in Europe and America, 1600–1850

Nature well-pleased at Art's Success
Each imitative grace shall see,
And Flora with approving smile
Shall twine her choicest wreaths for thee

Dr. Shaw, lines addressed to Dr. Thornton
on his Botanic Garden[1]

Several interwoven threads make up the history of botanical illustration in Europe and the United States. The first is the history of medicinal plants. Not surprisingly, many of the personalities who play a role in the story of botanical illustration were apothecaries by training, since as the repository of knowledge about the healing properties of plants, the apothecary (or pharmacist) was on intimate terms with members of the plant kingdom. Another thread of the narrative is the political history of the voyages of exploration and colonization. Gold and spices were not the only riches brought home to Europe as intrepid explorers investigated the far corners of the world. Botanic wealth was gathered as well, giving rise to a third thread, the history of science. For as exotic plant species began to enter Europe in great numbers, a new science, botany, was born to make sense of it all. The final thread is the history of printmaking. The evolution of printmaking techniques and the mastery of color printing are an essential part of the story. It is the print that makes the artist's original work available to a wide audience, spreading both the scientific information it contains and the artistic beauty it possesses.

Although this catalogue begins around 1600, it is preceded by a long tradition of botanical illustration. Illustrated herbals dating back to antiquity, mostly concerned with medicinal plants, were copied over and over again in manuscripts to document and transmit knowledge of the healing arts. Any mistakes due to human error were passed along through the different versions. With the development of the woodcut as a print matrix, identical, consistent information could be conveyed through repeated copies of an image. While the earliest woodcuts were often highly simplified, during the Renaissance several important botanical publications were illustrated with detailed, refined woodcuts made from direct observation of living plants (fig. 1). Leonhart Fuchs, the author and publisher of *De Historia Stirpium*, so valued the artistic team that produced the illustrations for his 1542 book that he included their portraits at the end of the volume. The relationship between draftsman and printmaker would remain a crucial one throughout the history of botanical illustration.

Great Gardens and Great Patrons

In 1613 an apothecary from Nuremberg named Basil Besler published a marvelous work called the *Hortus Eystettensis* (cats. 1–3) that marks the transition from the period of woodcut-illustrated herbals to large folio volumes illustrated with copperplate engravings. In this new printmaking technique, the artist's drawing was transferred to a copperplate using a burin, a tool that incised V-shaped furrows of varying depths into the metal. Ink was rubbed onto the plate, which was then wiped clean, leaving ink only in the incised design. When a sheet of paper was laid on the plate and passed through a press, the inked design was transferred to the paper. The resulting prints looked strikingly modern. Crisp and bold, the black-and-white images clearly delineated each plant's structure and captured fine details not possible with woodcuts.

Hortus Eystettensis also represents a transition from illustrations of medicinal herbs to images of plants for their own sake, to record their individual characteristics

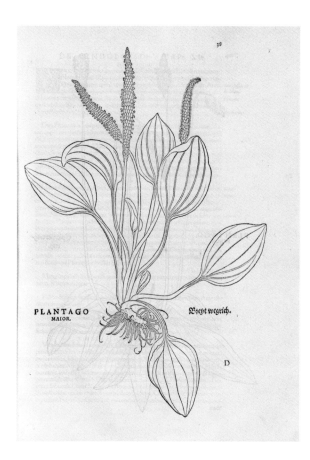

Fig. 1
Albrecht Meyer, Heinrich Füllmaurer,
and Veit Rudolf Speckle
Plantago Maior, from Leonhart Fuchs,
De Historia Stirpium (1542)
Woodcut
Gift of W. G. Russell Allen 38.655

The fruitful relationship between the bishop of Eichstatt and Besler is a model that is repeated often throughout the history of botanical illustration. A wealthy, enlightened individual—often a king or a prince of the church—who is a passionate collector of plants creates an outstanding garden and then seeks to preserve it in a collection of pictures. He or she becomes the patron of a talented artist or entrepreneur, subsidizing the publication of prints that immortalize the garden and, further, contribute to a growing body of knowledge about the plant world. France's Gaston d'Orléans, brother of Louis XIII, was such a patron, and the artist whose work he encouraged was Nicolas Robert, one of the most talented botanical artists of the seventeenth century. In 1650 Gaston engaged Robert to come to the Château de Blois to prepare a set of paintings on vellum based on his menagerie and botanic garden there. This collection is the origin of the celebrated repository of botanical drawings known as the *vélins du roi* (the king's vellums), today preserved at the Museum of Natural History in Paris.

Two Trends in Seventeenth-Century French Flower Painting

Robert's work, and that of his followers, represents one of two parallel trends that developed in French flower painting during the seventeenth century: the scientific approach to plant illustration. Jean-Baptiste Monnoyer and Jean Vauquer embody the second trend, a decorative tendency that came out of Dutch flower painting but was nourished by the fervent interest in flowers and garden design within France. Both styles emerged from the new passion for encyclopedic gardens that arose early in the century with the creation in 1626 of the king's Royal Garden of medicinal plants, the Jardin du Roi. Both were based on close observation of the natural world, but their aims were quite different.

Interest in botany as a science grew steadily throughout the seventeenth century, fostering a desire to illustrate

and beauty. Published in Nuremberg, the book documents the fabulous garden of the bishop of Eichstatt, a veritable Garden of Eden that contained exotic plants from all over the world. Besler helped the bishop plan the garden, and together they conceived the idea of creating a florilegium—a collection of flowers in a book—that would make its treasures more widely known. As a result, the garden was made permanent, and the book—which depicted more than 667 plant species in 367 engravings—constituted an invaluable reference to the botanical world of the epoch.

The influence of this great work was far-reaching. In Nuremberg, especially, it became a standard for later florilegia. Christoph Jacob Trew, an eighteenth-century medical doctor, botanist, and natural historian, preserved the original drawings, although the copperplates had been melted down. His own outstanding publications, and those of others from or nearby Nuremberg, such as Johann Volckamer, Johann Weinmann, and Georg Wolfgang Knorr, clearly drew inspiration from the majestic *Hortus Eystettensis*.

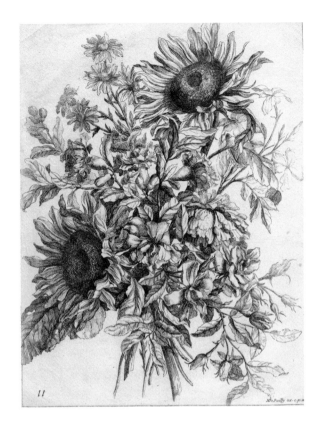

plants with the most accurate detail possible. During his stay at Blois, Robert was taught a more scientific method of draftsmanship by the Scottish botanist Robert Morison, who was the director of Gaston's garden and an early figure in the attempts to arrive at a system of classification for plants. In 1666 the French Academy of Sciences was founded, and one of its earliest projects was a major work on botany. By 1676 an initial, abbreviated, five-chapter version of the book *Mémoires pour servir à l'histoire des plantes* (*Memoirs Useful for the History of Plants*) by Denis Dodart appeared, illustrated with thirty-eight plates by Robert and two other artists, Abraham Bosse and Louis de Châtillon. Eventually, 319 plates—130 of them by Robert—were finished and printed, but there was no further publication; the project simply stopped. In the mid-eighteenth century, sets of prints were pulled from the plates and presented to select people as royal gifts under the title of *Recueil des plantes gravées par ordre du Roi Louis XIV* (*Collection of Plants Engraved by Order of King Louis XIV*). However, there was no wider distribution. Thus, the work that many deem the finest example of French botanical illustration of all time remained essentially unknown and without influence.

The decorative trend in French flower painting was far more visible. Jean-Baptiste Monnoyer epitomized this approach in his immensely successful career. He had trained in Antwerp and became a master of the techniques and compositions that characterized the grand floral still lifes of the Low Countries. Such works, featuring huge urns and baskets brimming with flowers, were much in demand by aristocratic clients for decorative projects in France and England. Both Monnoyer and Jean Vauquer (fig. 2) published etchings and engravings of their floral subjects, often in the form of pattern books for artisans and the industrial arts, thus helping to popularize the decorative manner. The style dominated French decorative arts and manufacture for more than one hundred years, and could still be seen at

the end of the eighteenth century in the work of Gerard van Spaendonck, Jean-Louis Prévost, and even Pierre-Joseph Redouté, who regarded his paintings as "valuable models to manufacturers."[2]

Etching was the preferred technique for reproducing drawings of billowing, sumptuous bouquets. Like an engraving, an etching was produced from inked lines incised on a copperplate. However, the plate was prepared differently. It was first covered with an acid-resistant ground; the drawing was made through this ground using a needle that exposed the copper; and the plate was then placed in an acid bath. The acid bit, or etched, grooves where the copper had been exposed by the needle. Though free and delicate, the technique was still linear. Different patterns of cross-hatching created shading and modeling, but subtle variations of tone that would give dimension to the subject or represent nuanced color shifts were not possible; if color was desired, it had to be applied by hand. Consequently, the search for ways to print in color became a major concern for botanical printmakers, even as the science of botany itself matured.

The Eighteenth Century: A Marriage of Art and Science

The known plant world burgeoned at the end of the seventeenth century and the beginning of the eighteenth. As European nations explored distant lands and established colonies in the Americas, South Africa, and Asia, botanical bounty flowed into the continent from all over the world. Renowned gardens like that of Abraham Munting in Groningen, Holland, were enriched with hundreds of new, exotic species, including some from Japan. Though Japan had been closed to the outside world since 1641, the Dutch East India Company was allowed to establish a trade mission on an island off the coast of Nagasaki. The German physician and naturalist Engelbert Kaempfer spent two years with the mission in the 1690s, bringing back information on Japan's plant life. Abraham Munting's *Naauwkeurige Beschryving der Aardgewassen* (cats. 8–9), published in 1696, is the source of some of the earliest information on Japanese flora and its importation into the West, nearly one hundred years before Carl Peter Thunberg's comprehensive study *Flora Japonica*.[3]

As botanists sought to bring order to this wealth of new plant material, botany and natural history became the intellectual pursuits most in vogue. The need for a system of classification dominated botanical discourse and was pursued by distinguished researchers such as John Ray and Hans Sloane in England and Joseph Pitton de Tournefort in France. All of these scientists were precursors to Carl Linnaeus, the Swedish botanist who would devise the most widely accepted taxonomic system in 1735.

The young science of botany formed a comfortable partnership with art in the work of the German artist Maria Sibylla Merian. Born in 1647, Merian became devoted to entomology, especially the life cycle of caterpillars and butterflies. Encouraged by her family to follow these interests, however unconventional for a woman, she trained as a flower painter in the Dutch still-life tradition and used this skill to depict the insect world in precise, realistic drawings. In 1679 she published a book of black-and-white engravings of caterpillars and

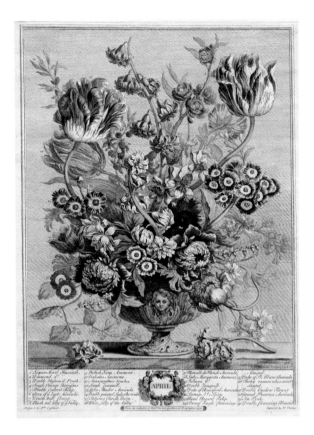

their host flowers (fig. 3). This publication was a preview of her magnificent 1705 work on the insects of Suriname, *Metamorphosis Insectorum Surinamensium* (cats. 10–11), one of the most acclaimed books in the history of botanical illustration. Merian was a deeply religious person. While her work was undeniably scientific, her art hints at larger truths about nature and creation, using confident, page-filling compositions to illuminate a spiritual relationship between the botanical and insect worlds. Her intense artistic vision influenced later illustrators, most notably Georg Dionysius Ehret, and her extraordinary life provided a model for other female botanical artists. Over the next 150 years, Madeleine Basseporte, Priscilla Bury, Anna Atkins, and others would pursue botany and scientific illustration with similar single-mindedness and success.

In the early eighteenth century, London and Nuremberg were the undisputed centers of botanical activity. Outstanding collections of plants, primarily based on new imports, had been formed in London (at the Chelsea Physic Garden) and in nearby Cambridge (at the Cambridge Botanic Garden). Sir Hans Sloane, whose collection of natural history specimens would later become the foundation of the British Museum, was head of the Royal Society in London. A preeminent figure in the world of botany, his presence at the society assured the advancement of the scientific study of plants. Furthermore, the city's coffeehouse culture provided a stimulating environment for the fruitful exchange of information and ideas. The Society of Gardeners, a trade organization of gardeners and nurserymen, was one group that took advantage of this open intellectual environment. Meeting at Newell's Coffee House during the 1720s to discuss their commercial offerings, they ultimately published a *Catalogus Plantarum* to establish a uniform nomenclature for the variety of plants available in the horticulture market. Their catalogue represented a change in the nature of the patronage of botanical

illustration—a publication subsidized by a commercial entity. This shift was also evident in the endeavors of independent nurserymen such as Robert Furber, whose *Twelve Months of Flowers* (fig. 4) and *Twelve Months of Fruits* were really deluxe catalogues of plants for sale.

In the Society of Gardeners' meetings, ideas about color printing arose, leading to a giant step in the technical history of botanical illustration. Both their *Catalogus Plantarum* and the *Historia Plantarum Rariorum* (cat. 14) by John Martyn, a founder in 1721 of the Botanical Society of London and a fellow of the Royal Society, were pioneer publications using a method of intaglio color printing—a type of mock mezzotint—developed by their countryman Elisha Kirkall. On the continent, Johann Weinmann of Ratisbon experimented with a similar technique invented by the Dutchman Johannes Teyler during the 1680s. These printing innovations were an attempt to break away from the linear syntax imposed by engraving and etching, in which areas of color had to be applied to the finished print by hand. The new color techniques were tonal, rather than linear. The metal plate was roughened

in the areas that would represent color, using special tools such as mezzotint rockers and roulettes. Colored inks were then applied there, dabbed on by a tool tightly wrapped with rags at one end—an inking method called *à la poupée*, because of the resemblance of the tool to a doll's head. When the plate and paper were run through the press, a colored print resulted. The inking was repeated for each run, and hand-coloring was still required for a finished look.

Meanwhile, in Nuremberg, Christoph Jacob Trew was the intellectual counterpart of London's Hans Sloane. Wealthy and dynamic, Trew was the major figure in the city's vibrant scientific community, and to realize his publishing projects, he assembled around him a circle of the most accomplished scientific illustrators. Foremost among the artists he discovered and encouraged was the man who would become the most influential botanical artist of the mid-eighteenth century, Georg Dionysius Ehret.

As a young artist with a talent for depicting plants, Ehret traveled through Western Europe, visiting the most important gardens and producing drawings, many of which Trew purchased. In 1735 he spent a month with the Swedish botanist Linnaeus at the home and gardens of George Clifford in Holland. There, the two men prepared the *Hortus Cliffortianus*, the first work to illustrate dissections of flowers as well as habits of plant growth. That same year, Linnaeus published his revolutionary *Systema Naturae*, his system of plant classification based on the sexual characteristics of flowers as represented by their reproductive organs, the stamens and pistil. With this publication, the entire botanical world came into focus; order emerged from chaos, as the plant families fell into ranks. Linnaeus's findings brought a revolutionary change to botanical illustration, shifting attention to the flowers themselves, whereas earlier styles of illustration had shown the whole plant—including roots, stems, and seeds. While some artists and botanists maintained allegiance to earlier systems, such as that of Tournefort,

the Linnaean system dominated botanical thinking and publication for the next seventy-five years.

Ehret's presence at this galvanizing moment in the history of botany placed him at the leading edge in the field of illustration. In 1736 he established himself permanently in England, where he rose to the top among scientific illustrators, overshadowing even talented contemporaries such as Jacobus van Huysum—brother of the renowned flower painter Jan van Huysum—and Peter Casteels. Ehret's extraordinary skill won him the patronage of Hans Sloane and the Duchess of Portland, the wealthiest woman in Britain, whose vast gardens at Bulstrode Park inspired many botanists and illustrators. He moved easily in English society and was much sought after as a teacher for aristocratic young ladies. His drawings of the unsurpassed collection of exotic plants in the Chelsea Physic Garden were sent to Trew, who published them in *Plantae Selectae* (cats. 23–25). Ehret's work is also richly represented in Trew's *Hortus Nitidissimis Floribus* (cats. 26–30), a beautiful florilegium of cherished garden flowers of the day.

On his own, Ehret published a charming and highly personal work entitled *Plantae et Papiliones Rariores* (cats. 18–20). For this collection, he not only made the drawings but did the engraving and coloring as well. The designs are less scientific than those he produced for Trew, but they are nonetheless filled with technical observations and notes that reveal his total engagement with his plant subjects. In this sense, and in its focus on both plants and butterflies, Ehret's book shows the influence of Maria Merian.

New Developments in France

Throughout this highly productive period in England and Germany, excellent French botanical artists continued to work in the scientific tradition. The coveted chair of painter in miniature to the king at the Jardin du Roi was held by a succession of talented artists following Robert,

all of whom contributed to the ever-growing collection of *vélins du roi*. These included Jean Joubert, Claude Aubriet, and Madeleine Basseporte. But the publications that could make their work widely known were still few. In this regard, it is interesting that the great tree specialist Duhamel du Monceau chose to illustrate at least one of his publications, the 1755 book *Traité des Arbres et Arbustes*, with woodcut illustrations from a sixteenth-century work rather than commission new work.

Flower painting in the decorative tradition continued to be very visible, with pattern books—such as those published by Roubillac, Louis-Marin Bonnet, and Louis Joseph Mondhare—still a popular way to meet the demand for floral motifs in the decorative arts industries of textile, wallpaper, and porcelain manufacture. Inventive new printmaking techniques developed to support this trend, including the crayon manner, which used special tools to expertly imitate the light and crumbly strokes of the crayon or pastel drawings so prized in the Rococo period. Artist-engravers like Bonnet and Charles Melchior Descourtis elaborated sophisticated color-printing methods that used as many as eight plates, achieving tour-de-force reproductions of works by Boucher, Fragonard, and other Rococo painters.

During the last quarter of the eighteenth century, French botanical illustration underwent an important transformation that in effect merged the parallel traditions of scientific and decorative flower painting and brought France to the forefront of botanical illustration in the next century. In 1769 the Dutch artist Gerard van Spaendonck arrived in Paris. Trained in the manner of Jan van Huysum, the brilliant eighteenth-century master of the traditional Dutch flower piece, Van Spaendonck began his career in France as a flower painter, not a botanical illustrator. While his early reputation was built on decorating luxurious accessories such as charming painted boxes, he also won important commissions to design the painted decors in some aristocratic homes.

Upon the death of Madeleine Basseporte in 1780, Van Spaendonck was awarded the post of professor of floral painting at the Jardin du Roi. Even though his work did not have an underlying botanical purpose like that of his predecessors at the Jardin, the vivacity and naturalness of his flowers were unrivaled in his day. Van Spaendonck's new duties, in addition to teaching, included supervision of the collection of the *vélins du roi*, to which he contributed fifty of his own works through the years. Initially these flower portraits were painted in gouache, but he developed an exquisite watercolor technique that came to characterize his style.

Beyond the original watercolors, Van Spaendonck's work can best be appreciated in his only publication, *Fleurs Dessinées d'après Nature* (cat. 55), a book of twenty-four stipple engravings based on his designs that appeared between 1799 and 1801. The uncolored versions of the plates demonstrate the superb craftsmanship of the talented engravers who interpreted Van Spaendonck's closely observed plant structures and lifelike modeling. Colored plates, made under the painter's supervision, reveal the nuanced subtlety of his watercolor technique (fig. 5).

But it is as a teacher that Van Spaendonck had his deepest influence on botanical art. He was both the culminating figure in the Dutch floral painting tradition that had been passed on through Van Huysum and the source from which a new tradition flowed. His students—who included Pancrace Bessa, Jean-Louis Prévost, Pierre Jean-François Turpin, Pierre-Antoine Poiteau, and Madame Henriette Vincent—went on to become some of the greatest botanical illustrators in France. Chief among this talented group was Pierre-Joseph Redouté, perhaps the most brilliant flower painter in history.

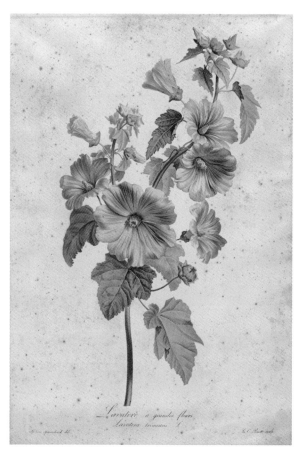

The Age of Redouté and Thornton: France and England in the Nineteenth Century

Born in Belgium, Redouté came to Paris in 1782 at the age of twenty-three. He had worked on his own as an itinerant artist since he was thirteen, a beginning very similar to that of Ehret. Passing through Amsterdam en route to France, he saw the work of Van Huysum, and from then on flower painting became his primary interest. In Paris the wealthy botanist L'Héritier de Brutelle, a committed Linnaean, noticed Redouté's exceptional drawings made in the Jardin du Roi and taught him how to make plant dissections and proper scientific representations of plants, opening his library to the young artist and introducing him to the best scientific and social circles. Van Spaendonck became another valuable mentor, providing additional introductions that furthered his career. Van Spaendonck's refined watercolor technique influenced Redouté's outstanding mastery of the medium. Based on close observation, Redouté's style was precise and detailed. His colors were transparent and delicate, and he probed the individuality of each flower.

On an extended trip to England with L'Héritier in 1786, Redouté was introduced to a new color printing technique that was to shape his future dramatically. He learned the stipple engraving method invented by the Italian Francesco Bartolozzi, a tonal approach in which masses of dots of varying density were applied to the printing plate with a pointed tool in areas that were to receive colored ink. This was the ultimate refinement of the cruder color printing methods developed by Elisha Kirkall earlier in the century. In the hands of a talented engraver, the new technique could be used to interpret all of the delicate nuances of the original artwork and then print them in color. With no engraved or etched lines, the print appeared softer, more luminous, and astonishingly fresh and natural. After his return to France, Redouté worked in this method and taught it to the teams of engravers whose excellent work was to contribute to his soaring reputation.

The type of comfortable international exchange that Redouté experienced during his time in London was soon disrupted by the French Revolution, followed by the long period of the Napoleonic Wars. For more than thirty years, botanical illustration in France and England proceeded along different paths. While artists like Van Spaendonck and Redouté weathered the many political transitions, interchanges between the two countries became rare.

Fig. 6
Sèvres Porcelain Manufactory
Pair of ice-cream coolers from the
Service des plantes de la Malmaison
(*Les Liliacées*), 1803–4

Hard-paste porcelain with
colored enamel and gilding
Gift of Mr. and Mrs. Henry R.
Kravis 2001.250a–c

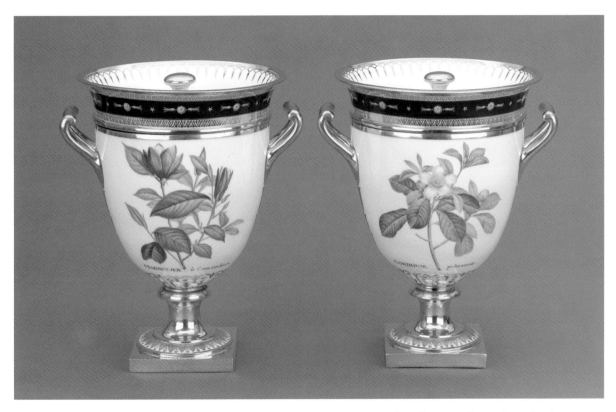

In France, Redouté and the Van Spaendonck school dominated the field. Redouté enjoyed patronage at the highest levels, producing an ongoing stream of beautiful and scientifically valuable books. His most famous works were made for Empress Josephine, who hired him at the turn of the nineteenth century to paint the magnificent botanic specimens in her gardens at Malmaison, her château outside of Paris. *Les Liliacées* (cats. 60–63) and *Les Roses* (cats. 73–74) are records of Josephine's achievement as a passionate and enlightened collector, on a level with her predecessors the bishop of Eichstatt and Gaston d'Orléans. Josephine so loved Redouté's beautiful portraits of her garden that she commissioned a 108-piece

dessert service based on *Les Liliacées* from the Sèvres Porcelain Manufactory (fig. 6).

Redouté had always considered his drawings apt models for manufacturers, as seen in the dessert service. He specifically emphasized this use of his work in the preface to his beautiful late publication *Choix des Plus Belles Fleurs* (cats. 78–79). In this florilegium, Redouté allowed himself the luxury of showing beautiful garden flowers for their own sake, with no underlying scientific purpose. Yet he commented in his preface that the whole edifice of flower painting rested upon botanical study and the close observation of nature.

In England, several figures rose to the top of the field

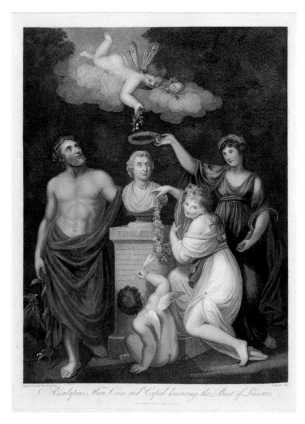

with innovative publishing ventures, and many notable
works emerged out of the ongoing excitement surrounding
botany and horticulture. In 1787 the botanist and gardener
William Curtis began publishing *The Botanical Magazine*
(cats. 43–47), a periodical in a small octavo format aimed
at a wider public than the luxurious, learned folios that
had so far characterized botanical publications. Three
hand-colored engravings of exotic plants that had become
popular garden choices were published in each issue, along
with scientific details and information on their cultivation.
The magazine was immensely successful and still exists
today. In the course of producing it, Curtis became the
patron of several major artists and engravers who worked
with him for many years.

By far the most outstanding English project was Dr.
Robert John Thornton's *Temple of Flora* (cats. 48–54),
which was issued between 1799 and 1807 as part three
of his *New Illustration of the Sexual System of Carolus von
Linnaeus*. With family wealth to back him, Thornton
conceived of this ambitious project to pay homage to
Linnaeus, engaging the best draftsmen and engravers
to make the thirty-two color-printed plates. Exquisite
calligraphic title pages, portraits, and three elaborate
pictorial allegories were part of the deluxe presentation. It
was unique in that each flower was depicted in a dramatic
landscape representing its home habitat.

Charged with the emotional spirit of Romanticism, the
book was a literary as well as pictorial work. The artists,
who were not all trained botanical illustrators, took
poetic license with the scientific accuracy of their plants
and landscapes, in keeping with the odes to the goddess
Flora, to Linnaeus, to the individual flowers, and even
to Thornton himself that accompanied the images. A
bust of Linnaeus was the subject of a beautiful full-page
allegorical design in which Aesculapius, Ceres, Flora,
and Cupid—the pantheon that governed the vegetable
kingdom—paid tribute to the botanist (fig. 7).

Nothing like this publication had been attempted

before in botanical illustration. If Besler's *Hortus
Eystettensis* was symbolically the Garden of Eden, it was
nonetheless totally grounded in the bishop's real garden.
Thornton's "botanic garden" was an artistic construct;
his *Temple of Flora* was an emotional vision of nature's
vegetable realm. The intellectual premise behind it
differed markedly from that of his French contemporary
Redouté, who at the same time was working on the
monumental *Liliacées* and other strictly botanical books
and who was concerned with the rigorous observation
and recording of that same kingdom of nature.

A Changing Focus: From Complete Gardens to Single Species

Thornton's publication had embraced the natural world
but had pointedly moved away from the approach of the
"rigid botanist," while striving, as he noted in his preface,
for "universal approbation." George Brookshaw, the
English author and artist of *Pomona Britannica* (cat. 72),
another fine color-plate book of the period, took a similar
anti-botany position. Botany, he felt, had been emphasized

at the expense of horticulture. His work aimed, through its strikingly graphic aquatint illustrations and knowledgeable commentaries, to offer advice on the best varieties of fruits for the gentleman's garden. It was a thoroughly practical, though deluxe, guide.

Other works concerned with varieties, albeit from a botanical point of view, were those dedicated to a single genus of certain flowers in fashion, such as roses or camellias. Mary Lawrance's *Collection of Roses from Nature*, issued in 1799, was the first such work. Henry Charles Andrews's *Roses* (cats. 69–71) followed several years later. The most splendid of the rose books was Redouté's *Les Roses*, which was published between 1817 and 1824. Each artist felt he had outdone his or her predecessor in the beauty and accuracy of the designs. There is no doubt, however, that the technical perfection and delicate coloring of Redouté's plates make them among the most beautiful of all botanical illustrations.

Camellias, which had arrived in Europe from Japan in the early eighteenth century and had been depicted in fifty-one botanical works since then,[4] became wildly popular in art and literature in the nineteenth century. Five spectacular aquatints by Clara Maria Pope illustrated Samuel Curtis's *Monograph on the Genus Camellia* (cats. 75–77), an 1819 book dedicated exclusively to this beautiful flower. A French work with illustrations by Johann Jakob Jung, the *Iconographie du Genre Camellia* (cats. 85–87), began to appear in parts in 1839. Published by Abbé Laurent Berlèse, it was based on his celebrated collection of camellias. In a kind of Linnaean progression, botanical illustration had evolved from depictions of entire gardens representing the flora of the earth to representations of the myriad varieties of a single plant species.

Botanical illustration arrived at perhaps the ultimate destination of this increasingly specific knowledge of the plant world in the 1854 publication *Victoria Regia; or the Great Water Lily of America* (cats. 88–93). This mammoth folio described the flowering cycle of the exotic Victoria Regia in a sequence of six plates, thus chronicling a scientific happening in the life of a particular plant. The water lily's blooming was of great interest not only to botanists but also to the general public, who came from great distances to see this marvelous event. Through a single celebrity plant, an intimate mystery of the vegetable world was made visible.

Lithographic Techniques

Published in Boston, *Victoria Regia* was illustrated with six chromolithographs designed and printed by William Sharp for John Fisk Allen, an amateur botanist who had grown this rare water lily—only the second one in the United States—in a special hothouse in Salem, Massachusetts. Lithography and color print lithography (called chromolithography) were the most important new print technologies of the early nineteenth century, and the first lithographic botanical illustrations had been printed around 1811.

The technique was based on the antipathy of grease and water. An artist made a drawing in greasy crayons or ink on a special fine-grained stone, which was then soaked in water. When ink was applied to the stone, it adhered to the design, not to the wet stone. Paper was laid on the inked stone and run through the press, creating the print. Lithography was a planographic process, meaning it was printed from a flat surface, unlike the intaglio techniques of engraving and etching, in which ink was held in grooves incised in the printing plate.

One marvelous advantage of lithography was that the artist's ideas were immediately accessible. There was no intermediate step in which another craftsman who engraved or etched the design into a printing plate interpreted the original drawing. Of course, it was sometimes convenient or necessary to have a lithographer prepare the stone from someone else's original designs. In Robert Wight's *Icones Plantarum Indiae Orientalis*, for example, the large number of

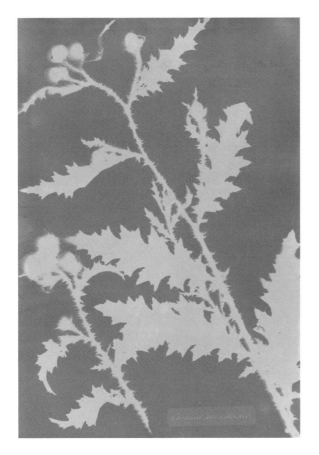

drawings made in India by two native artists, Rungiah and Govindoo, were prepared for printing by European artists, probably in Scotland.

Another advantage was the relative economy and ease of the lithographic process, which contributed to its popularization. Charming botanical books by very capable amateur artists were not uncommon in the 1820s and 1830s. With this popularization came sentimentality, and collections of poetry illustrated with botanical drawings came into vogue. Fine hand-colored lithographs

by James Andrews accompanied poems by Louisa Ann Twamley in a book titled *Flora's Gems*, advertised as a "unique ornament for the drawing room table." These lovely, though lightweight, publications are very distant descendants of the majestic poetry and art of *The Temple of Flora.*

Color printing of lithographs was not perfected until 1837. Based on the use of several stones inked in different colors, chromolithography is a painstaking process that requires the perfect registration of the paper on each successive stone. William Sharp, who brought the process to the United States from England in 1840, was a master of the difficult technique. The chromolithographs he made for *Victoria Regia* are based on his own drawings, and his delicately colored images are considered the cornerstone of American color printing.

The End of an Era: The Impact of Photography

The invention of photography in 1839 brought an end to traditional botanical illustration—beautiful images of plants, colored or not, made in ink on paper. Soon, scientific specimens could be recorded directly, in exact detail, and with compelling immediacy by the camera. The new photographic image was chemical. Its continuous tone was seemingly without syntax, in contrast to the lines and dots of the intaglio techniques. For many decades, no adequate color process existed in photographic printmaking. Nonetheless, the old models influenced the new medium.

The first photographic images, called photogenic drawings, were botanical. Scientist and inventor William Henry Fox Talbot produced the silhouettes of leaves and ferns laid against light-sensitive paper. Anna Atkins, an amateur botanist and talented natural history illustrator, used this type of cameraless photograph in her 1843 publication on British algae (the first photographically illustrated book) and in a later work titled *British and Foreign Flowering Plants and Ferns* (fig. 8). Such collections

Acknowledgments

resemble the earlier botanical publications in intent and concept. With improvements in the quality and sharpness of the photographic image, photographers such as Charles Aubry and Adolphe Braun portrayed flowers and bouquets in documents used by the textile industry, continuing the French concern for art and industry that had developed in the seventeenth century.

Throughout the golden age of botanical illustration, a key goal expressed by many of the participants, from Basil Besler to William Sharp, had been that of making the garden permanent. The artists and printmakers, and their successors the photographers, were the agents of that dream. Redouté defined the botanical artist as one "whose paintbrushes give lasting existence to the ephemeral gifts of Flora."[5] As the examples in this catalogue illustrate, botanical art is indeed a marriage of science and beauty, in which exact records of scientific import are endowed with an aesthetic presence that can approach spiritual revelation.

Gardens in Perpetual Bloom was made possible by the expertise and help of the following individuals at the Museum of Fine Arts, Boston; the Nagoya/Boston Museum of Fine Arts; and the Massachusetts Horticultural Society:

Cliff Ackley, David Becker, Victoria Binder, Kristen Borg, Anna Bursaux, Gail English, Katherine Getchell, Karen Haas, Greg Heins, Natsuko Hido, Satoko Inokuchi, Hitomi Inoue, Albert Lewis, Alison Luxner, Paul McAlpine, Terry McAweeney, Annette Manick, Nayu Miyasaka, Jared Medeiros, Patrick Murphy, Mark Polizzotti, Tom Rassieur, Joseph Scheier-Dolberg, Jodi Simpson, Suzanne Sroka, Elizabeth Thomas, and Sarah McGaughey Tremblay.

Special thanks are due to Stephanie Loeb Stepanek, who first proposed that I work with her on the Museum's collection of botanical illustrations and who curated the exhibition. She gave unstintingly of her time and experience. Her extensive knowledge of the history of prints, and of the art of botanical illustration, has made her an invaluable guide through this stimulating material.

In the catalogue section beginning on p. 23, plates have been grouped according to the printed book in which they originally appeared. Each grouping is introduced by a page of commentary, followed by the plates themselves. For ease of identification, plates have been numbered sequentially.

1 Dr. George Shaw, in Dr. Robert John Thornton, *The Temple of Flora; or Garden of Nature. Picturesque Botanical Plates of the New Illustration of the Sexual System of Linnaeus* (London: 1799–1807).

2 Redouté, preface to *Choix des Plus Belles Fleurs* (1827), cited in *Redouté's Fairest Flowers*, by William T. Stearn with Martyn Rix (London: Herbert Press in association with the Natural History Museum, 1987), 20.

3 W. P. Watson Antiquarian Books, *Bibliopoly*, s.v. "Munting, Abraham. *Naauwkeurige Beschryving der Aardgewassen*," http://www.polybiblio.com/watbooks/2800.html (accessed April 1, 2009).

4 Gordon Dunthorne, *Flower and Fruit Prints of the 18th and Early 19th Centuries* (1938; New York: Da Capo Press, 1970), 263.

5 Redouté, preface to *Choix des Plus Belles Fleurs*, cited in *Redouté's Fairest Flowers*, by Stearn and Rix, 20.

Basil Besler
(German, 1561–1628)
Hortus Eystettensis
Eichstatt and Nuremberg: 1613;
2nd edition, 1640; 3rd edition, 1713

1

Large Sunflower (Flos Solis Maior),
1713 edition
Design possibly by Basil Besler
(German, 1561–1628)
Engraving by unidentified artist
(German, early 17th century)
Coloring by unidentified artist
(German, 18th century)

2

Three Varieties of Leucoium (I. Leucoium
purpureum variegatum flore pleno. II.
Leucoium pleno flore album purpureis
maculis signatum. III. Leucoium pleno flore
album sanguineis maculis signatum),
1713 edition
Design possibly by Basil Besler
(German, 1561–1628)
Engraving by unidentified artist
(German, early 17th century)

3

I. Lady's Slipper. II. Blue Variegated Bearded
Iris. III. Dark Variegated Bearded Iris. (I.
Calceolus Mariae. II. Iris Portugalica. III.
Iris Pannonica variegata), 1713 edition
Design possibly by Basil Besler
(German, 1561–1628)
Engraving by unidentified artist
(German, early 17th century)
Coloring by unidentified artist
(German, 18th century)

Basil Besler's *Hortus Eystettensis* is an iconic work in the history of
botanical illustration. Published in 1613, the magnificent folio
commemorates the most important botanical garden in northern
Europe, that of the bishop of Eichstatt, near Nuremberg. Beginning in
the 1590s, Bishop Johann Conrad von Gemmingen used his vast wealth
to create a garden that included almost every known plant in the world.
The bishop knew the great botanists of his day and purchased each new
plant that made its way to Europe through the flower centers of the
Netherlands, Antwerp and Brussels. He was aided in his ambitions by
Besler, a pharmacist and gardener from Nuremberg who helped to plan
the garden and later undertook to make a permanent record of it in a
book of prints.

The scale of the publishing project was immense. The best engravers in
Nuremberg, working after drawings made by artists brought to Eichstatt
(and probably some by Besler himself), made 367 copperplate engravings
representing 1000 flowers (667 plant species). Organized according to
season, the designs depicted the flowers straight on in detailed, life-size
portraits. The prints were made on the largest paper available (the size
called "royal"), and the confident technique of the engravers captured the
bold, baroque magnificence of the drawings.

Two versions of the 1613 edition were printed on paper of different
qualities. Three hundred copies on ordinary paper carried descriptive
text on the back and were intended for professional botanists and
naturalists. Thirty copies on a superior grade paper had no text and could
be hand-colored with no risk of the color bleeding through; enormously
expensive, they were destined for heads of state. A second edition was
issued in 1640 and a third in 1713, one hundred years after the original
book was published. These examples are from the third edition.

The bishop of Eichstatt died before this monumental work came to
fruition, and the garden itself was destroyed during the Thirty Years War
(1618–1648). However, it lived on in the plates of *Hortus Eystettensis*, just as
the bishop and Besler had hoped. The book provides an invaluable record
of a flowering garden around the year 1600, and it became a standard and
an inspiration for later florilegia.

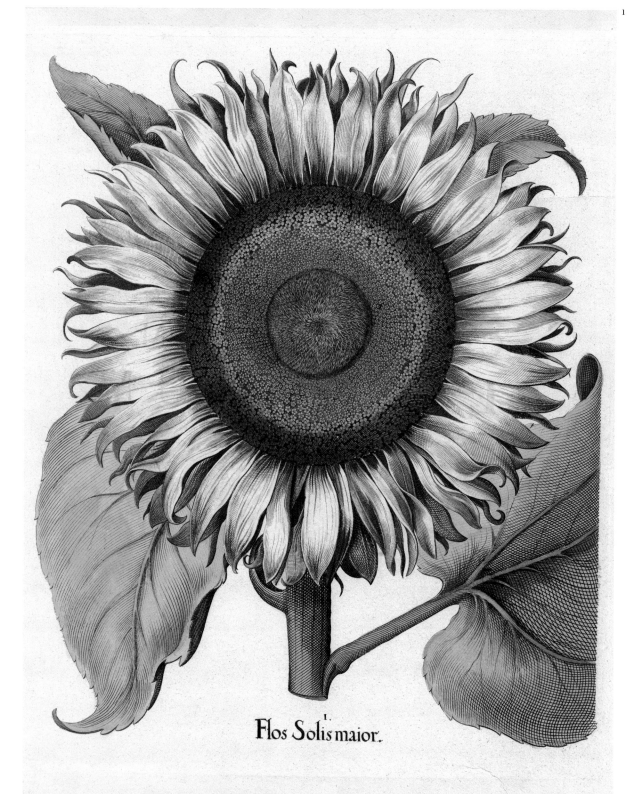

Flos Solis maior.

32

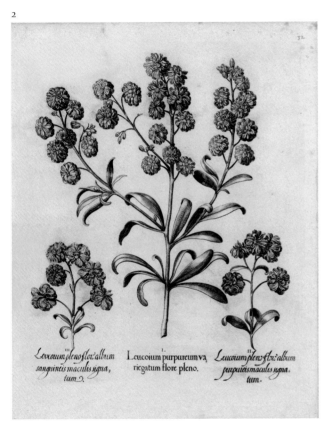

III
Leucoium pleno flor. album
sanguineis maculis signa.
tum.

I.
Leucoium purpureum va
riegatum flore pleno.

II
Leucoium plens flr. album
purpureis maculis signa.
tum.

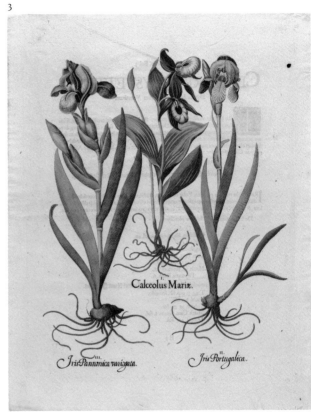

I.
Calceolus Mariæ.

III.
Iris Pannonica variegata.

II.
Iris Portugalica.

4

Nicolas Robert
(French, 1614–1685)
Variae ac Multiformes Florum
Species appressae ad Vivum et
æneis tabulis incisae
Paris: after 1669

Nicolas Robert was one of the most important botanical artists in France during the seventeenth century, and this book was among his earliest works, first published in the early 1640s. Our print is from a later edition. The folio's title page and thirty engravings of flowers demonstrate Robert's skill as a draftsman and an engraver, exhibiting his close observation and meticulous craftsmanship. Each flower is identified and some are shown with insects (butterflies, beetles, and caterpillars), predating by sixty years the all-encompassing naturalist's view made famous by Maria Sybilla Merian.

The beauty of the book, whose title translates as *Various Species of Flowers Drawn and Engraved after Nature*, undoubtedly contributed to the selection of Robert to illustrate a celebrated florilegium called the *Guirlande de Julie*, an intimate and lovely album of flower pictures, poetry, and calligraphy offered to the daughter of the French noblewoman Madame de Rambouillet by her fiancé. That work made Robert's name in aristocratic circles, and he was subsequently chosen by Gaston d'Orléans to illustrate all of the flowers and animals in Gaston's important botanical garden and zoo at Blois. He would go on to make many of the drawings for Denis Dodart's *Mémoires pour servir à l'histoire des plantes (Memoirs Useful for the History of Plants)*, sponsored by the new Academy of Sciences. The Academy's project was never realized as first conceived. Three hundred nineteen of the plates were published separately in 1767, but these were only offered as royal gifts, and not made available to the public. Robert's plates for it remain among the most beautiful seventeenth-century botanical illustrations. Their scientific relevance contrasts with his early drawings, which, while full of naturalistic observations, were more akin to ornamental flower painting.

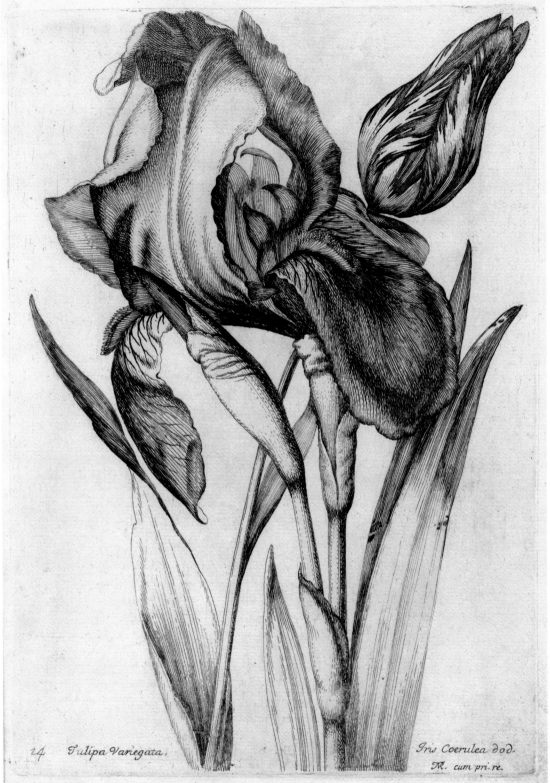

14. *Tulipa Variegata.*

Iris Coerulea dod.
M. cum pri. re.

5–7

Jean-Baptiste Monnoyer
(French, 1634–1699)
Livre de Toutes Sortes de Fleurs
d'après Nature
Paris: 1660–80

5

Arrangement of Roses, Jonquils, and
Campanula in a Glass Vase
Design and etching by Jean-Baptiste
Monnoyer (French, 1634–1699)

6

Arrangement of Roses, Jonquils, and
Campanula in a Glass Vase
Design, etching, and coloring by Jean-
Baptiste Monnoyer (French, 1634–1699)

7

Tulips and Hyacinths in a Glass Vase
Design and etching by Jean-Baptiste
Monnoyer (French, 1634–1699)

Through his artistic training in Antwerp, Jean-Baptiste Monnoyer was exposed to the school of flower painting that grew up and flourished in the Low Countries in the seventeenth century, and he became a master of the decorative flower piece. Upon Monnoyer's return to France, the painter Charles Le Brun noticed his work and involved him in important decorative projects at Versailles and other royal residences. Additional aristocratic clients followed. Monnoyer (or Baptiste, as he sometimes called himself) also worked for the Gobelins manufactory, designing floral borders for tapestries. His great success earned him a place in the French Royal Academy of Painting and Sculpture by 1663. He spent the last twenty years of his life in England, working for the same sort of clientele.

Monnoyer's beautiful paintings were grand compositions of baskets and urns overflowing with flowers that were prized for their inventiveness and naturalism. He was one of the earliest practitioners of the decorative tradition in French flower painting, a style that contrasts with the scientific focus of his contemporaries Nicolas Robert and Claude Aubriet, who were primarily botanical illustrators. Nonetheless, Monnoyer's flowers were keenly observed and botanically accurate. He made many engravings in the style of his paintings. His important book *Livre de Toutes Sortes de Fleurs d'après Nature* provided charming examples in several different categories—such as Baskets of Flowers, Garlands, and Small Bouquets Tied with a Ribbon—that were probably intended as models for designers and craftsmen.

These three engravings are from the category Arrangements in Glass Vases. Two are from the same plate, and one of these is colored by hand. The three images share a compositional type: a glass vase holding a small but full arrangement of flowers sits on a ledge and casts a shadow. The glass containers allowed Monnoyer to showcase his skill as an engraver at representing both transparency and reflections, devices that were well-established features in the still-life flower painting at which he excelled. As was typical in this period, many of Monnoyer's bouquets contain flowers that bloomed in different seasons. He would have made individual drawings from fresh flowers and then used them wherever a form added strength to a composition. Thus, a luxuriant parrot tulip is at home with a chrysanthemum, and roses and narcissi peacefully coexist.

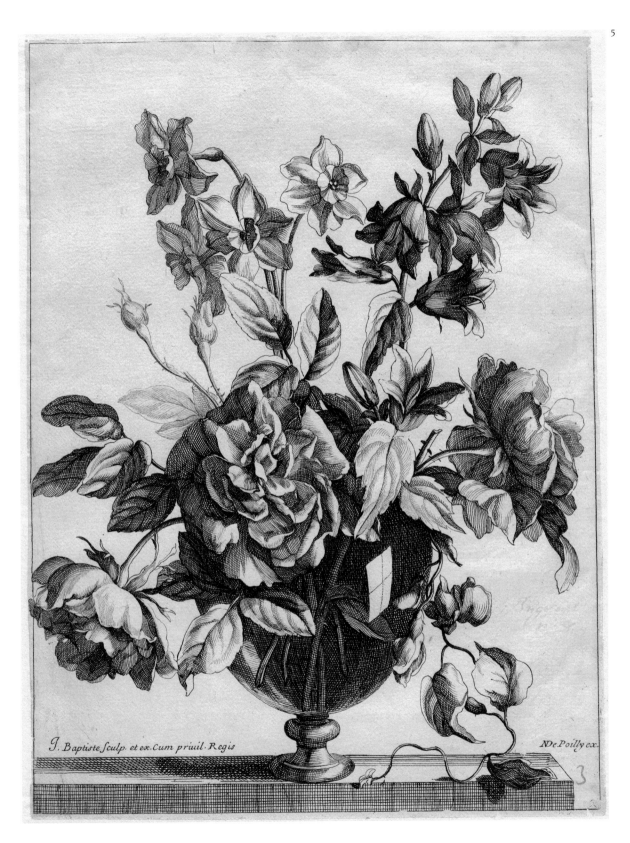

J. Baptiste *sculp. et ex. Cum priuil. Regis*　　　　　　　　N de Poilly ex.

6

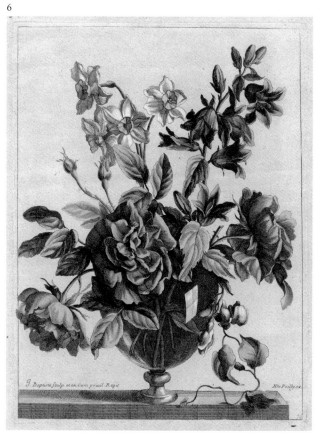

7

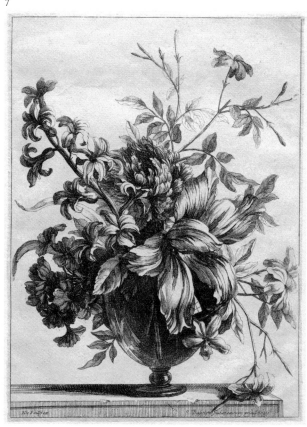

8–9

Abraham Munting
(Dutch, 1626–1683)
Naauwkeurige Beschryving der
Aardgewassen
Leyden and Utrecht: 1696

8

Chimney Bellflower (Campanula
Pyramidalis minor)
Design by unidentified artist
(Dutch, 17th century)
Engraving and coloring by unidentified
artist (Dutch, 17th century)

9

Indian Morning Glory (Convolvulus Indicus
pennatus)
Design by unidentified artist
(Dutch, 17th century)
Engraving and coloring by unidentified
artist (Dutch, 17th century)

Abraham Munting was a medical doctor and professor of botany at Groningen University, where he also directed the botanical garden started by his father. Known as the Paradise of Groningen, this was one of the most celebrated gardens of its time. It grew in size, fame, and importance as Munting received seeds from colleagues all over the world, especially from regions of Dutch colonial expansion in the Americas, South Africa, and Asia.

In 1672 Munting published his first book, which described 677 of the exotic plants in his garden, illustrated with forty plates. The prints shown here come from a posthumous, much expanded work published in 1696 that was illustrated with 243 engravings made from drawings in Munting's collection. Landscape backgrounds and plant identifications were added at the request of the publishers. Among the plates are some of the earliest depictions of Japanese flora seen in the West.

The names of the artists and engravers of this beautiful florilegium are mostly unknown. Only one plate is signed—by the engraver Joseph Mulder, whose name is also associated with fine plates in Maria Sibylla Merian's *Metamorphosis Insectorum Surinamensium* (cats. 10–11). It is thought that classical details and architectural elements such as the base of a pyramid seen here in *Campanula Pyramidalis minor* are the work of the engraver Jan Goeree, who was responsible for the beautiful title page of the book.

A striking innovation in this collection is the depiction of the plant in monumental scale against a very small landscape background. This discrepancy in proportion can make the plants seem as large as trees. In some cases, they simply float above the landscape as though the image were composed of two different paintings. The style, in fact, can be seen as an amalgam of two important trends in Dutch painting of the period: the fashion for all-encompassing bird's-eye views of landscapes or townscapes; and the interest in flower painting of all kinds, including botanical portraits such as these. Other characteristics of the Munting plates include the flowing ribbons and the pieces of architecture inscribed with plant names.

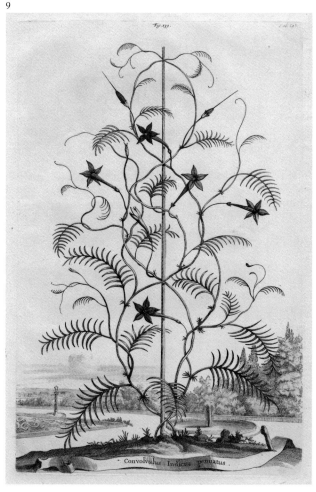

Maria Sibylla Merian
(German, 1647–1717)
*Metamorphosis Insectorum
Surinamensium*
Amsterdam: 1705

10

Watermelon with Caterpillar and Moth
Design by Maria Sibylla Merian
(German, 1647–1717)
Etching and coloring by Pieter Sluyter
(Dutch, 1675–about 1713)

11

Apple of Sodom (Pomme de Sodome)
Design by Maria Sibylla Merian
(German, 1647–1717)
Etching and coloring by Pieter Sluyter
(Dutch, 1675–about 1713)

One of the most original personalities in the history of botanical illustration, Maria Sibylla Merian dedicated her life to pursuits that were highly unusual for a woman of her time, ultimately earning success and respect for her work. Her major publication, *Metamorphosis Insectorum Surinamensium*, was the result of two years spent in the hot, humid climate of Suriname from 1699 to 1701. Published in Dutch and Latin editions, it contains sixty plates illustrating many different species of insect and plant life in this South American country. The book is a monument to Merian's single-minded pursuit of entomology, specifically caterpillars and their life cycle. Their pupae and cocoons, the butterflies and moths that emerged, the laying of new eggs, and the emergence of a new generation of caterpillars had held her interest from the age of thirteen.

This fascination led Merian to examine and depict the plants on which these creatures fed, and her art thus encompassed botanical as well as entomological illustration. She had studied painting with her stepfather, the Dutch flower painter Jacob Marrel, who taught her the techniques of painting in watercolor on vellum. Her early work reflects her period's taste for floral still life. Realistic insects were part of the repertoire of trompe l'oeil devices used in this genre of painting, and Merian was ready and able to include them in her watercolors. This was the beginning of the happy marriage of art and science that characterized her work from then on.

However, as seen in *Metamorphosis*, her mature art reflects a closer relationship to botanical art like that of Besler's *Hortus Eystettensis* (cats. 1–3), of which she owned a copy, than to seventeenth-century flower painting. Merian made and colored some of the plates herself, but Pieter Sluyter and Joseph Mulder did the majority of the etchings based on her drawings. Large, close-up portraits of the plants allowed Merian to portray the insects life-size, an important concern when introducing new, exotic species to her European audience. Devices such as the cut-open fruit have been retained from the still-life tradition, but here they become a magnified backdrop for the fantastic and colorful insect life. Although some have criticized Merian's botanical work as inaccurate, her bold compositions paint an uncompromising portrait of the intertwined worlds of plants and animals.

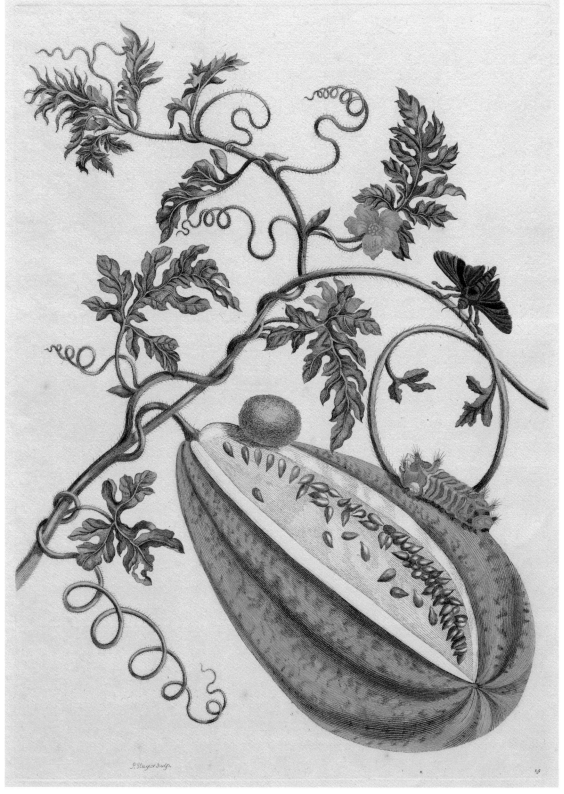

P. Sluyter Sculp.

XXVII.

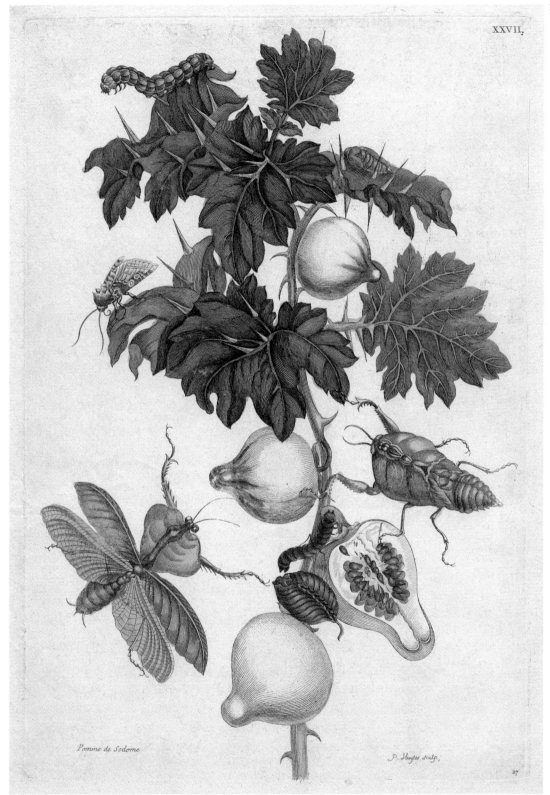

Pomme de Sodome

P. Huylee sculp.

12–13

Johann Christoph Volckamer
(German, 1644–1720)
Nürnbergische Hesperides, 2 vols.
Nuremberg: 1708

12

*Triple-Flowered Egyptian Datura (Datura
Aegyptia: Flore triplici seu pleno)*
Design by Paul Decker
(German, 1677–1713)
Engraving and coloring by unidentified
artist (German, 18th century)

13

*Indian Phaseolus
(Phaseolus Indic: cochleatus)*
Design by Paul Decker
(German, 1677–1713)
Engraving and coloring by unidentified
artist (German, 18th century)

The wealthy Nuremberg merchant Johann Volckamer created one of the greatest gardens in the city in the early eighteenth century. On a trip to Italy as a young man, he was fascinated by the cultivation of citrus fruits. He became heavily involved with the fashionable aristocratic pastime of growing citrus and tropical fruits in the cold Nuremberg climate, a hobby that required special greenhouses called orangeries, eventually forming the largest collection of this botanical family north of the Alps.

The *Nürnbergische Hesperides* was an outgrowth of this passionate interest. It involved many years of planning and collecting the drawings, beginning in the 1690s. Published in two volumes of five parts each, the book was primarily devoted to the different varieties of citrus. However, the last part of volume one was dedicated to flowers, two of which we see here set against a background of country scenes representing the environs of Nuremberg. The finest German artists and engravers made 247 plates for the work. Volckamer's artistic conception is characterized by a dramatic visual game in which an immense fruit or flower is portrayed hovering, like an alien vessel, over a miniaturized, but actual, view of a townscape, maritime scene, grand country home, or garden. Although the botanical specimens themselves are magnificent, the detailed views of the topography, architecture, and gardens are equally important. This same device of contrasting scale had been used by Abraham Munting in 1696 (see cats. 8–9).

Volckamer must certainly have been inspired by the great botanical work of the preceding century, the *Hortus Eystettensis* of Basil Besler (cats. 1–3), a celebrated production of Nuremberg ateliers. The large scale of his fruits and flowers and the bold and strong engraving recall, in a more relaxed way, Besler's parade of stately flowers. The bird's-eye views were typical of Paul Decker, who signed some of the plates. The Hesperides of the title refers to the Greek myth of the nymphs who tended Hera's golden apples in the goddess's beautiful garden. For Volckamer, the spectacular gardens of Nuremberg represented that mythical paradise. Here, he was also influenced by a noted Italian work of the seventeenth century, Giovanni Ferrari's *Hesperides*, a learned study on the citrus family published in 1646.

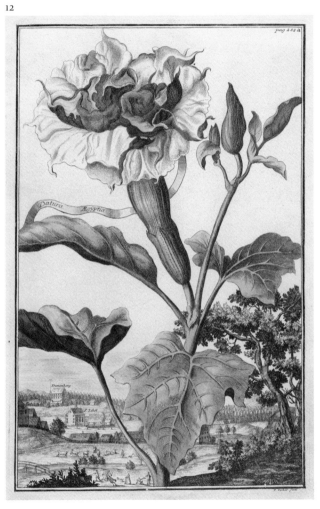

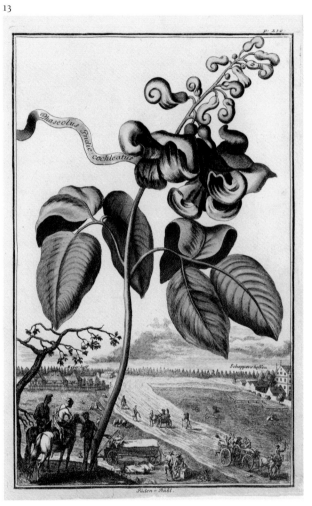

John Martyn
(English, 1699–1768)
Historia Plantarum Rariorum
London: 1728

*Maryland Wild Senna (Cassia Marilandica
pinnis foliorum oblongis, calyce floris
reflexo)*
Design by Jacobus van Huysum (Dutch,
active in England, 1687/89–1740)
Engraving and color printing by Elisha
Kirkall (English, about 1682–1742)

John Martyn's *Historia Plantarum Rariorum* exists in the MFA's collection as a complete book, providing the opportunity to see botanical prints in their original context, accompanied by a scholarly, descriptive text. The splendid folio volume contains fifty mezzotints by Elisha Kirkall after drawings by various artists; they were issued in groups of ten prints called decades. Each illustration faces a page of text and is decorated with a coat of arms, possibly belonging to subscribers or members of the Royal Society, of which Martyn was a member. *Cassia Marilandica*, which was drawn by Jacobus van Huysum, bears the name of William Dickins, L.L.D.

Martyn held the chair of botany at Cambridge University and was superintendant of the Apothecaries' Garden at Chelsea (later the Chelsea Physic Garden). *Historia Plantarum Rariorum* is illustrated with exotic species from the Americas that were growing there and in the Cambridge Botanic Garden. The folio's great significance is that its illustrations are the first examples of botanical plates printed in color. This fact alone has assured the work its important place in the history of botanical illustration. The engraver, Kirkall, developed an intaglio technique that combined etching with mezzotint, a pioneering form of the stipple engraving procedure that allowed for tonal color printing and would be used with marvelous skill later in the eighteenth century by artists such as Gerard van Spaendonck and Pierre-Joseph Redouté.

Although *Cassia Marilandica* was printed only in green ink, Kirkall's technique achieved a surprising range of tones, giving the print a sparkling liveliness. The deepest grooves of the engraved plate held the most ink and printed as a deep, rich green, while the mezzotint used on the leaves created subtle transitions from dark to transparent tones of green, lighting up the plant and adding sheen to the leaves. Other prints in Martyn's book were printed in up to three colors—red, brown, and green.

Cassia Marilandica pinnis foliorum oblongis, calyce floris reflexo.

Gulielmo Sherard LLD
Iuris Civilis apud Cantabrigienses
Professori Regio.

J. van Huysum pinx.

E. Kirkall fc.

Johann Wilhelm Weinmann
(German, 1683–1741)
Phytanthoza Iconographia, 4 vols.
Ratisbon: 1737–45

15

Bamboo
Design by unidentified artist
(German, 18th century)
Etching, engraving, and coloring by
Bartolomaüs Seuter (German, 1678–1754)

16

*Three Varieties of Turk's Cap Lilies (a. Lilium
Martagon Imperiale moschatum / b. Lilium
Martagon angustifolium rubrum / c. Lilium
Martagon purpureo sanguineum flore
reflexo)*
Design by unidentified artist
(German, 18th century)
Etching, engraving, and coloring by
Bartolomaüs Seuter (German, 1678–1754)

17

*Four Varieties of Marigolds (a. Tagetes
Indica maxima flore pleno fistuloso / b.
Tagetes Indica major flore simplici fistuloso /
c. Tagetes seu flos Africanus major flore
pleno aureo / d. Tagetes Indica major flore
aureo simplici)*
Design by unidentified artist
(German, 18th century)
Etching, engraving, and coloring by
Bartolomaüs Seuter (German, 1678–1754)

Johann Weinmann's *Phytanthoza Iconographia* is remarkable in many respects, not least for the immense scale of the project. Planned by Weinmann, an important apothecary in Ratisbon, and financed by Bartolomaüs Seuter, one of the engravers, the complete multivolume work contained 1025 plates and illustrated more than 4000 species. Often, several varieties of a plant were illustrated in one plate, as demonstrated by the lilies and marigolds shown here. The project's far-reaching aim was described in the extended title: to survey thousands of domestic and foreign plants from all over the world.

Phytanthoza Iconographia represents the first continental use of color printing techniques in botanical illustration, a development seen in England a few years earlier in John Martyn's *Historia Plantarum Rariorum* (cat. 14) and in the *Catalogus Plantarum* published by the Society of Gardeners. Weinmann's publication used the method invented in 1688 by the Dutch experimenter Johannes Teyler, a mock mezzotint technique through which tonal gradations could be achieved by inking selected areas of the plate with various colors before passing it through the press. Pioneering though it was, *Phytanthoza* was a transitional work, with many of its plates still produced by traditional etching, engraving, and hand-coloring.

One of the first artists Weinmann chose for his project was the young Georg Dionysius Ehret, who would become the most famous botanical illustrator of the age. In the early 1730s, when he signed on to produce drawings for *Phytanthoza Iconographia*, Ehret was a penniless, itinerant artist. His relationship with the abrasive Weinmann soured, and Ehret left in a dispute over miserable wages after producing more than five hundred drawings. Weinmann published some of these in his book. It was the first publication of Ehret's work, and although he received no credit for the drawings, they are recognizable by their distinctive, monumental style.

Other notable artists and engravers also worked for Weinmann, including J. J. Haid, who later engraved Ehret's drawings for Christoph Jacob Trew's *Plantae Selectae* (cats. 23–25). Trew dismissed some of the Weinmann plates as drawn by artists with little botanical knowledge. In spite of this uncharitable opinion, Weinmann's publication was a great achievement both as a technical innovation and as an invaluable record of the plants grown and esteemed in the early eighteenth century. It was influential far beyond Europe; in nineteenth-century Japan, the great botanical artist Iwasaki Tsunemara found inspiration in the work for his celebrated treatise *Honzô Zufu*.

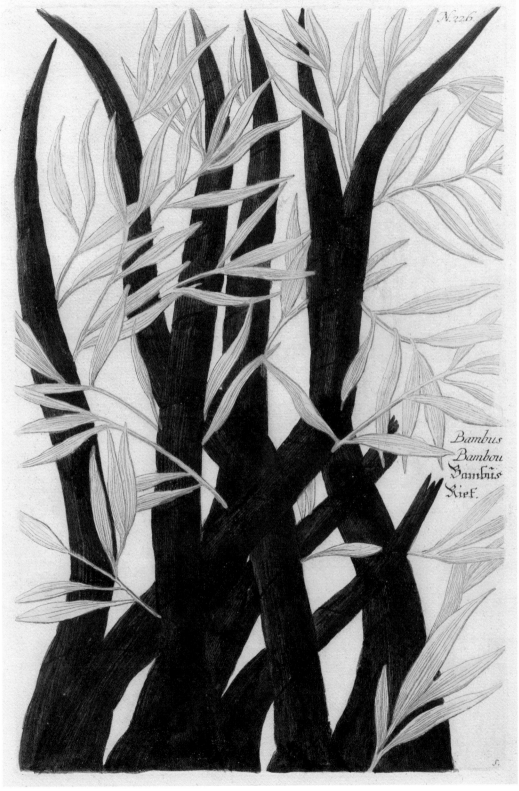

Bambus
Bambou
Bambus
Rief.

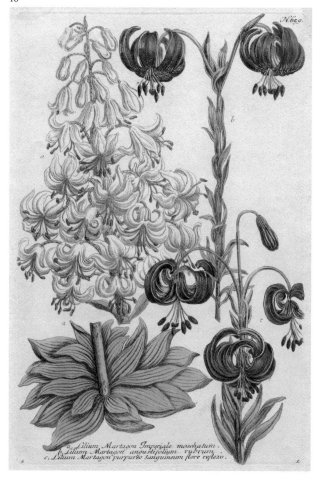

a. Lilium Martagon Imperiale moschatum.
b. Lilium Martagon angustifolium rubrum.
c. Lilium Martagon purpureo sanguineum flore reflexo.

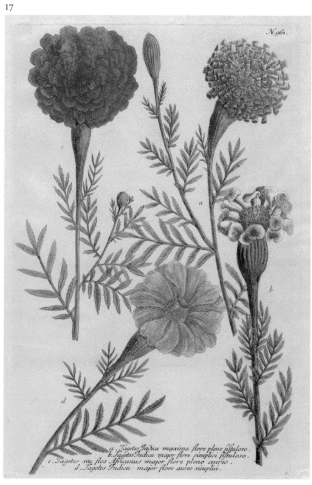

a. Tagetes Indica maxima flore pleno fistuloso.
b. Tagetes Indiæ major flore simplici fistuloso.
c. Tagetes seu flos Africanus major flore pleno aureo.
d. Tagetes Indica major flore aureo simplici.

18–20

Georg Dionysius Ehret
(German, 1708–1770)
***Plantae et Papiliones Rariores
Depictae et Aeri Incisae a Georgio
Dionysio Ehret***
London: 1748–59

18

*Martynia and Scotch Broom (1. Martynia
annua, villosa et viscosa, folio subrotundo,
flore magno rubro. 2. Martynia annua,
villosa et viscosa, Auris folio albo tubo
longissimo. 3. Cytisus procumbens
Americanus flore luteo ramosissimus qui
Anil supeditat apud Barbadensium Colones)*
Design, etching, engraving, and coloring
by Georg Dionysus Ehret
(German, 1708–1770)

19

*Small Climbing Cactus (Cereus minimus
scandens polygonus)*
Design, etching, engraving, and coloring
by Georg Dionysus Ehret
(German, 1708–1770)

20

*I. Papaya / II. Chickweed / III. Millet Grass (I.
Papaya / II. Anagallis / III. Gramen
Panicum)*
Design, etching, engraving, and coloring
by Georg Dionysus Ehret
(German, 1708–1770)

Georg Ehret was one of the preeminent botanical draftsmen of the eighteenth century. Born into a family of professional gardeners in Erfurt, Germany, he showed an aptitude for drawing at an early age. His artistic renderings of the unusual plants found in some notable gardens of the region attracted the attention of important botanists and collectors of botanical art, particularly the physician Christoph Jacob Trew of Nuremberg. Trew became a patron, mentor, and lifelong friend to the young artist, who soon was earning a living from his botanical drawings. Traveling in Europe and England, Ehret drew in the most distinguished gardens and met the most important botanical scientists of the day, such as Bernard de Jussieu in Paris and Carl Linnaeus in Leiden, Holland. In 1736 he settled in London.

Ehret's *Plantae et Papiliones Rariores* was published by subscription. It consists of fifteen plates depicting exotic plants then growing in London's famous gardens (some species represented for the first time) and the butterflies associated with them. The plates are distinguished by a freshness and immediacy of conception. Ehret took a comprehensive and naturalistic view of the plants, often including and labeling several subsidiary plants that might be found with the main subject in nature. The accompanying texts are primarily in Latin, although occasionally Ehret wrote in charming, conversational English as well. His keen graphic and textual observations convey a vivid sense of his background as a professional gardener and plant lover.

The book's significance in Ehret's extensive oeuvre is that the entire work—the original drawings, the engravings, and the coloring—is by Ehret himself. It thus reflects a complete personal vision of the unique conjunction of art and science that comprises botanical illustration.

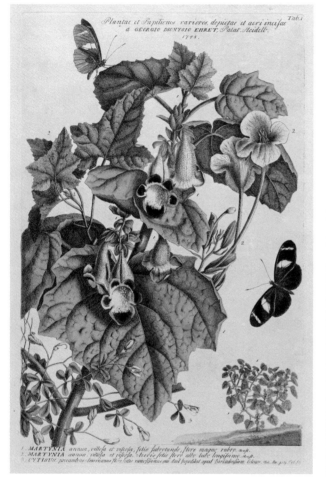

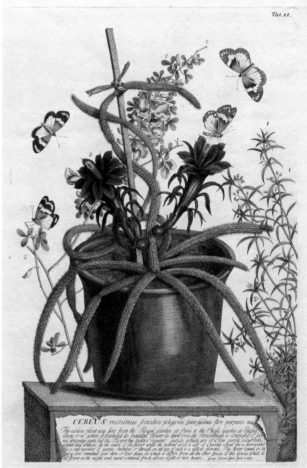

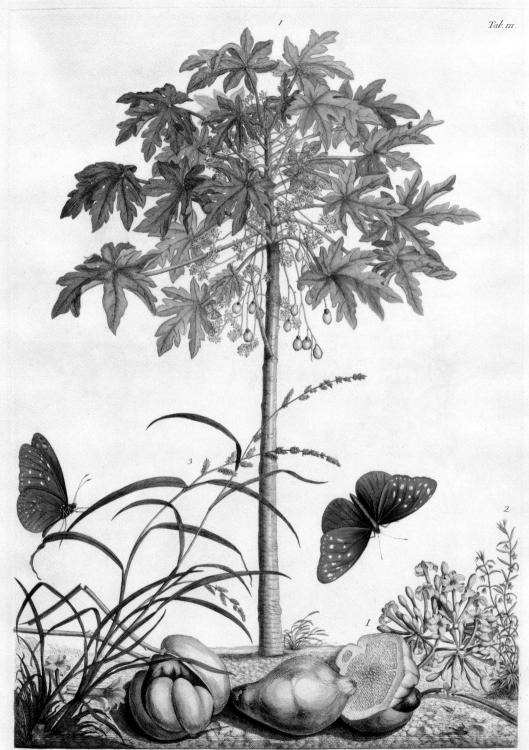

1

3

2

1

PAPAYA *mas. Boerh.Ind. Hæc planta alta erat quatuordecim pedes, diametri septem unciarum cum prima vice in Europa fructus ferret, et eos quidem maturos, die XXX Januarii Anno MDCCXIII in Horto instructissimo Dr Bavinci Petri, qui olim spes erat certa, Jam desiderium ingens est Botanices.*
ANAGALLIS *foliis lanceolato-linearibus, Caule ramoso diffuso. grenen* 3. GRAMEN *panicum minimum humifratum spica divisa mutica.Sloan Cat.*

G.D.E.

Georg Wolfgang Knorr
(German, 1705–1761)
Thesaurus Rei Herbariae
Hortensisque Universalis, 2 vols.
Nuremberg: 1750–72

21

Reddish Balsam Apple (Momor dicapomis
angulatis, tuberculatis, foliis glabris patenti
patinatis. Lin. H. C.)
Design, engraving, and coloring by Georg
Wolfgang Knorr (German, 1705–1761)

22

Single-Flowered Red Peony (Paeonia flore
simplici rubro)
Design, engraving, and coloring by Georg
Wolfgang Knorr (German, 1705–1761)

During the Enlightenment, Nuremberg had become a center of scientific publishing. Lavish illustrated volumes on subjects such as conchology, paleontology, and zoology were produced there, often based on Nuremberg collections. The city already had a long tradition in plant collecting and in published botanical illustration, beginning with the monumental 1613 florilegium *Hortus Eystettensis* and continuing in the works of Johann Volckamer and Christoph Trew, as well as that of Johann Weinmann in nearby Ratisbon. Georg Knorr, a contemporary of Trew and part of his stimulating circle, was a talented Nuremberg engraver who had published several important folio works on natural history, including botany.

Knorr began his *Thesaurus* in 1750. Publication of this ambitious flower book stretched out over many years, even beyond Knorr's death in 1761, and in fact was never finished. We know that the latest edition appeared in 1780, but the book's complicated bibliographic history remains to be sorted out. Knorr's intent was to include flowers, herbs, trees, and fruit, with descriptive texts in Latin and German written by Phillip Gmelin and Georg Boehmer. These two associates continued the publication of the *Thesaurus* after Knorr's death. Knorr drew, engraved, and colored most of the plates himself, basing many of them on images by Georg Ehret, whose illustrations were being made more widely known through Trew's contemporaneous botanical publications.

The style of Knorr's work is less refined than that of Ehret, but the illustrations are bold and striking; while not highly naturalistic, they are vigorously alive. The feathery coloring of the peony blossom, for example, is a disconcerting, though attractive, surprise. Cross sections and scientific details are not subdued, as in many botanical drawings, but instead are relatively large and as brightly colored as the featured plant. In both ambition and execution, Knorr's publication is a worthy successor to its illustrious Nuremberg precedents.

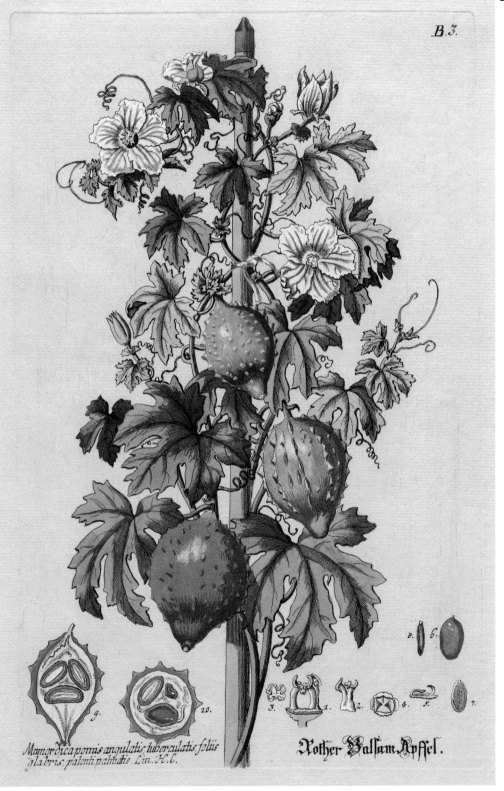

Momordica pomis angulatis, tuberculatis, foliis
glabris, patenti palmatis. Lin. H.C.

Rother Balsam Apfel.

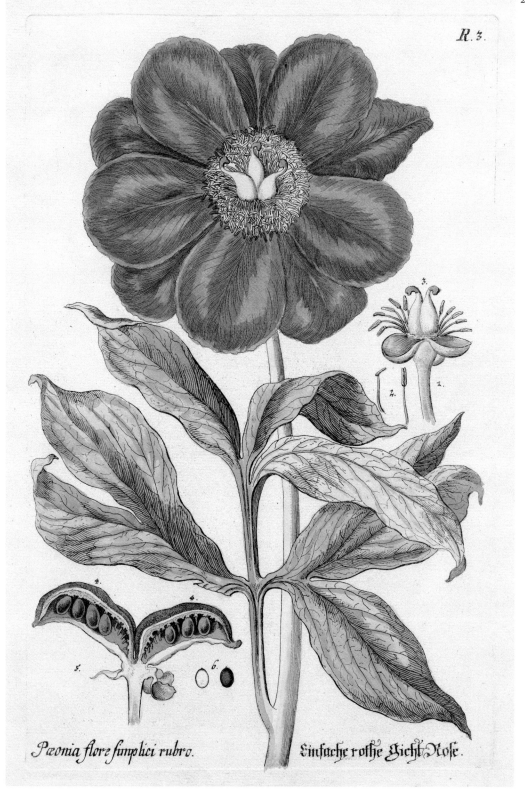

Pæonia flore simplici rubro. Einfache rothe Gicht Rose.

Christoph Jacob Trew
(German, 1695–1769)
Plantae Selectae
Nuremberg: 1750–73

23

Thorny-Leaved Bromelia (Bromelia foliis aculeatis)
Design by Georg Dionysius Ehret
(German, 1708–1770)
Engraving and coloring by J. J. Haid or J. E. Haid (German, 18th century)

24

Long-Leaved Magnolia (Magnolia foliis ovato oblongis)
Design by Georg Dionysius Ehret
(German, 1708–1770)
Engraving and coloring by J. J. Haid or J. E. Haid (German, 18th century)

25

Papaya (Fructu oblongo melonis effigie)
Design by Georg Dionysius Ehret
(German, 1708–1770)
Engraving and coloring by J. J. Haid or J. E. Haid (German, 18th century)

The medical doctor and apothecary Christoph Jacob Trew had established his career in Nuremberg by 1720. Since these two professions were historically linked to the study of botany, it is not surprising that Trew became one of the great patrons of botanical art in the eighteenth century. A respected and learned man, he amassed an important natural history collection that included the drawings for Basil Besler's *Hortus Eystettensis*, the iconic work of botanical illustration from the seventeenth century. In 1733 Trew befriended the young artist Georg Ehret, whose drawings of plants had come to his attention. They formed a working relationship that lasted until the end of their lives. As Ehret's patron, Trew taught him how to look at plants more scientifically and to emphasize elements of interest to botanists.

Trew's *Plantae Selectae*, which appeared between 1750 and 1773, was based on drawings of exotic plants that Ehret made in London, where he had lived since 1736. During this period, English collecting interests focused on new species brought back from the voyages of exploration. Trew's publication introduced these specimens to a wider audience and secured Ehret's reputation as one of the foremost botanical artists of the eighteenth century. Its one hundred plates were engraved and hand-colored by J. J. Haid and his son. Ehret's drawings were well served by the Haids, who were considered among the best engravers working in Nuremberg. They translated his imposing style with perfect understanding in both their engraving techniques and their coloring skills.

Ehret's bold close-ups are quite different from the more complete view of his subjects that he used in his own book, *Plantae et Papiliones Rariores* (cats. 18–20). His page-filling compositions exhibit the structure of branches and blossoms, show leaves from front and back, and include smaller, subsidiary drawings of specific sexual parts, seeds, and seedpods. They are as descriptive as any botanist would want, yet they are charged with a visual excitement that makes them more than scientific studies. In Ehret's drawing of a magnolia, for instance, the splendor of a single white flower standing out against enormous blue-green leaves exemplifies his ability to portray the awe-inspiring essence of this rare American plant.

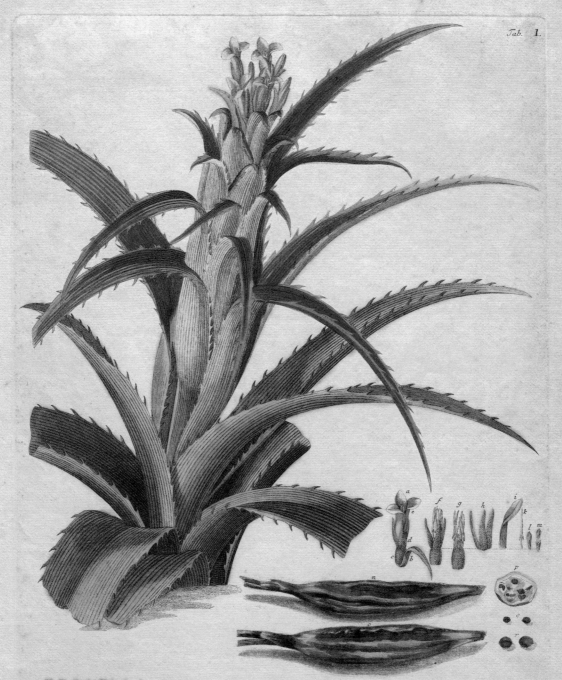

BROMELIA *foliis aculeatis, caule racemo laxo terminatrici Linn. H. Cliff. p. 129.*

a. flos integer cum foliolo b ovarium. c. involvente, d. calyx trifolius, e. corolla tripetala, f. stamina a corolla et g. a calyce separata, h. calyx separatus, i. petalum, k. stamen, l. stylus cum stigmate trigono, m. stigma transverse sectum, n. fructus maturus siccus, o. idem ex maceratione tumidior, p. eius transverse secti amplitudo cum seminum triplici ordine, q. semina matura, r. in magnitudine aucta.

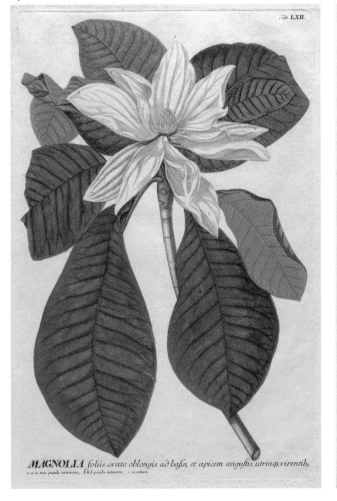

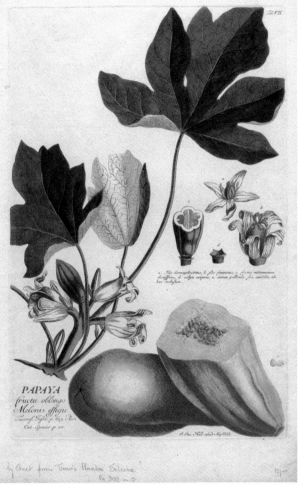

Tab. LXII.

Tab. VII.

MAGNOLIA *foliis ovato oblongis ad basin, et apicem angustis, utrinq; virentib.*
a. a. a. tria petala exteriora, b.b.b. petala interiora, c. ovarium.

PAPAYA
fructu oblongo
Melonis effigie
Tournef. Geffr. p. 659 Plum.
Cat. Spener p. 20.

26–30

Christoph Jacob Trew
(German, 1695–1769)
**Hortus Nitidissimis omnem per
annum superbiens floribus**, 3 vols.
Nuremberg: 1750–92

26

Anemone II (Bisard d'Angleterre), 1750–66
Design by Georg Dionysius Ehret
(German, 1708–1770)
Engraving and coloring by J. M.
Seligmann (German, 1720–1762)

27

*Rosa V, Large Provincial Rose (Rosa
Provincialis major)*, 1764
Design by Georg Dionysius Ehret
(German, 1708–1770)
Engraving and coloring by Adam Ludwig
Wirsing (German, 1733/34–1797)

28

*Tulipa V, Double White-Edged Tulip (Double
blanc bordé)*, 1750–66
Design by August Wilhelm Sievert
(German, active about 1750–1760)
Engraving and coloring by Adam Ludwig
Wirsing (German, 1733/34–1797)

29

Auricula III, 1769
Design by Johann Karell (German, active
1760–1780)
Engraving and coloring by Adam Ludwig
Wirsing (German, 1733/34–1797)

30

*Iris Anglica I, Queen Esther (Königin
Esther)*, 1764
Design by I. I. Meyer (German, 18th century)
Engraving and coloring by Adam Ludwig
Wirsing (German, 1733/34–1797)

Trew's *Hortus Nitidissimis Floribus*, the greatest florilegium of the eighteenth century, was concerned with the beauty of flowers typically found in the gardens of the day, in contrast to his *Plantae Selectae* (cats. 23–25), which focused on rare and exotic plants. As the full title explains, the publication illustrated "the flower garden in finest bloom throughout the year, or pictures of the most beautiful flowers." The three-volume work contained 188 plates and was published over forty-two years. Because of this extended publication period, it is exceedingly rare to find a complete set. Nevertheless, *Hortus Nitidissimis Floribus* is considered one of the finest records of the cultivated flowers of its time.

Although the work is generally attributed to Trew and was, indeed, based on his fabulous collection of botanical drawings, the publication was undertaken by the artist-engraver Johann Michael Seligmann. After Seligmann's death, production continued under the direction of Adam Ludwig Wirsing, a noted natural history engraver. Georg Ehret, who by now had become the leading botanical illustrator of the day, is represented in the work by forty plates, more than any other artist. However, the artistic team assembled for the project involved many talented artists, including Barbara Dietsch, Nikolaus Friedrich Eisenberger, Johann Christoph Keller, and August Wilhelm Sievert. The two publishers, Seligmann and Wirsing, did the engraving.

Because *Hortus Nitidissimis Floribus* is focused on the individuality and grace of the ornamental flowers of the period, the plates are less scientific than those of *Plantae Selectae*. Very lightly engraved lines, nearly covered over by a heavy gouache coloring, characterize images that look almost like the original drawings. Ehret's *Rosa V, Large Provincial Rose* (cat. 27), with its luminous, complex blossom painted in layers of pink and white, exemplifies this technique. A text in Latin and German, printed in side-by-side columns, accompanies each class of flowers.

Bifard d'Angleterre.

Eh.

ROSA V.

Rosa Provincialis major, flore pleno ruberrimo.
Boerh. Ind. alt.
46.

Cheel pinx.　　　　A.L.Wirsingk. excud.Norimbergæ 1764.

TVLIPA V.

Double blanc borde

J.M.Seligmann grad. Norimbergæ.

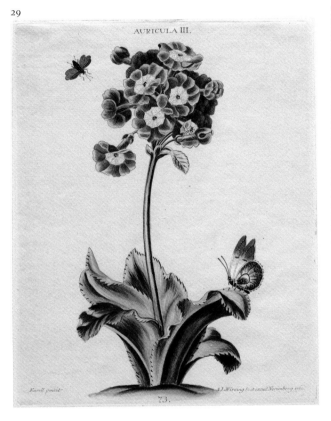

AURICULA III.

Karell pinxit *A.I.Wirsing Sc. et excud. Norimberg 1765.*

73.

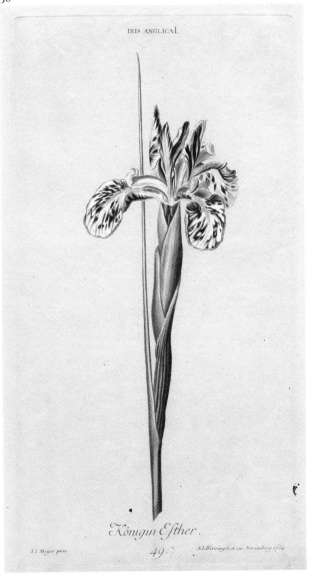

IRIS ANGLICAI.

Königin Esther.

I.I. Meyer pinx. *A.I.Wirsing Sc et exc. Norimberg 1764.*

49.

John Hill
(English, 1706–1775)
Exotic Botany
London: 1759

Double Crimson Hibiscus
Design by John Hill (English, 1706–1775)
Engraving and coloring by unidentified
artist (English, 18th century)

John Hill was one of the most extraordinary personalities in the history of botanical illustration and, indeed, in the history of his time. His entire, energetic life was a balancing act between his quarrelsome and aggressive character and his immense productivity as a great popularizer of natural history. Trained as an apothecary, he set up shop in London's Covent Garden, where he sold medicines and pamphlets on medicinal plants. Hill loved botany and searched out interesting specimens for aristocratic collectors on wide-ranging forays. After 1750, he began to earn a living from his writings. His 1751 *History of Plants* introduced the plant classification system of Linnaeus to England. However, in *The British Herbal* of 1756, he abjured the Swedish botanist and promoted his own system.

Hill had as much to communicate visually as he did with his fluent pen. He often favored a design style characterized by a crowded page packed with illustrations of many different plants. The *Double Crimson Hibiscus*, from his 1759 publication *Exotic Botany*, illustrates a single plant but in a composition that fills the page with many blossoms and leaves. Their all-over variegated coloring contributes to a sense of restlessness and movement in the print. A page of text accompanied each plate in the book. Many of the plants had come to Hill from China as dried specimens, and he included a description of a maceration technique through which he revived the plants to their original form in order to draw them.

Between 1759 and 1775, Hill undertook the publication of an immense twenty-six-volume folio entitled *The Vegetable System*. He hired the best artists and engravers, who illustrated 26,000 plants on 1600 copper plates. Unfinished at his death, the work ruined him financially.

Opinions vary as to Hill's scientific accomplishments. He was refused admittance to the Royal Society, and William Curtis (whose own botanical publications began to appear shortly after Hill's death) commented that his work was "voluminous but useless." Dr. Robert John Thornton treated him more kindly, including his portrait among a group of historically important botanists and associating him with laying out the Royal Botanic Garden at Kew in 1759. History acknowledges Hill as a man of ability and genius who, in spite of his disagreeable character, did more to diffuse the knowledge of botany in England than any of his contemporaries.

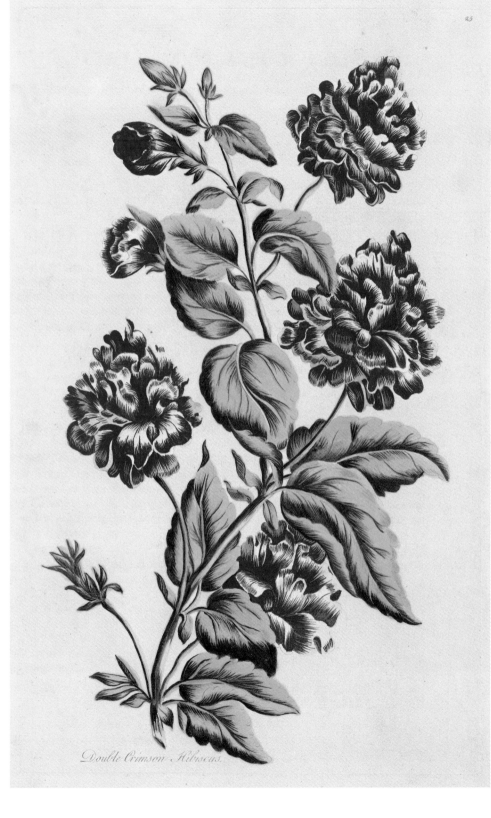

Double Crimson Hibiscus.

32–35

Giorgio Bonelli
(Italian, 1742–1782)
Hortus Romanus, 8 vols.
Rome: 1772–93

32

Prickly Acanthus (Acanthus aculeatus)
Design by Cesare Ubertini
(Italian, active 18th century)
Engraving and coloring by Magdalena
Bouchard (Italian, active 18th century)

33

African Geranium (Geranium Affricanum)
Design by Cesare Ubertini
(Italian, active 18th century)
Engraving and coloring by Magdalena
Bouchard (Italian, active 18th century)

34

Pink-Flowering Rush (Butomus flore roseo)
Design by Cesare Ubertini
(Italian, active 18th century)
Engraving and coloring by Magdalena
Bouchard (Italian, active 18th century)

35

Common Periwinkle (Pervinca vulgaris)
Design by Cesare Ubertini
(Italian, active 18th century)
Engraving and coloring by Magdalena
Bouchard (Italian, active 18th century)

Published by Giorgio Bonelli, a physician and professor of medicine in Rome, the eight-volume *Hortus Romanus* is extremely rare, with only three hundred copies issued. It documents the great eighteenth-century Botanical Garden of Rome, which grew out of the Vatican Garden founded by Pope Nicolas V in the fifteenth century. The portrait and dedication to the current pope, Clement XIV, as well as the portraits of cardinals that introduce the different volumes, indicate the garden's relationship to the church. Volume one is adorned with a magnificent double-plate bird's-eye-view illustration of the garden as it looked during the papacy of Nicolas V.

Bonelli worked on the publication with Liberato Sabbati, director of the Botanical Garden, and later with Sabbati's son, Constantine. The book represents a transitional moment when ideas about plant classification systems were still in flux. The first volume is organized according to the system developed by the French botanist Joseph Pitton de Tournefort. Although the subsequent volumes continue with Tournefort's system, they add the Linnaean binomial classification of plants as well.

The monumental work was illustrated with eight hundred engraved and etched plates, and some copies were colored by hand. The preface to volume one states that the flowers and vegetables were to be painted by Cesare Ubertini and engraved by Magdalena Bouchard. Although Bouchard signed only nine plates as the engraver, Gordon Dunthorne (author of a seminal work on the fruit and flower prints of this period) believed, based on style, that she engraved and colored the entire work. She was the daughter of the print publisher Giovanni Bouchard, of the firm Bouchard et Gravier, a printer long established in Rome and favored by the artist Giovanni Battista Piranesi.

The engraving of so many plates for an important publication was a job of considerable responsibility, and is certainly one of the most significant projects awarded to a woman artist at the time. Bouchard's confident hand seems fully suited to the vigorous style of the drawings. Highly decorative, each design fills its page to bursting and is surrounded by a narrow colored border. While the bold, rustic style sets the *Hortus Romanus* apart from contemporaneous works appearing in Paris, London, and Nuremberg, it nonetheless provides a striking portrait of a historic Italian botanical garden of the eighteenth century.

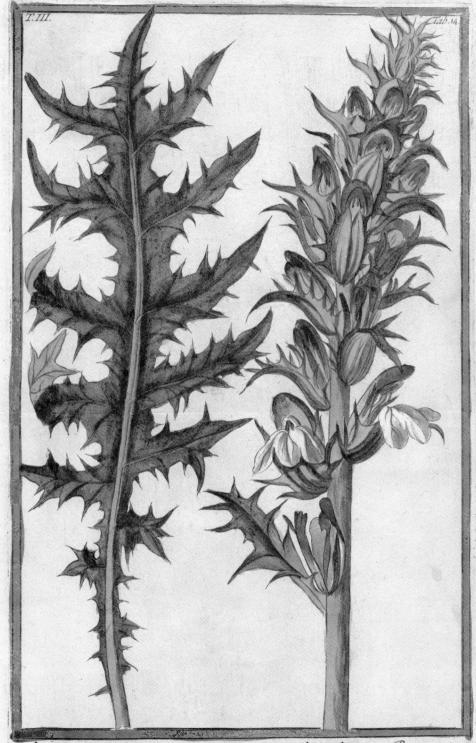

Acanthus aculeatus. C.B.Pin.383. — Carduus Acanthus, sive Branca Ur-
sina spinosa. J.B.3.75. — J.R.H.176. — Ital. Acanto. — Gall. Acante

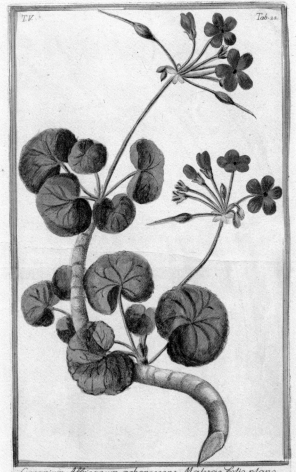

33

Geranium Affricanum arborescens Malvae folio plano.
Ital. Ago di Pastori. Gall. Bec de Grue.

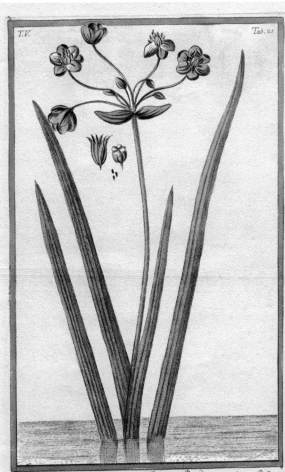

34

Butomus flore roseo. J. R. H. 271. Juncus floridus major. c.B.Pin.12.
Ital. Giunco florido maggiore.

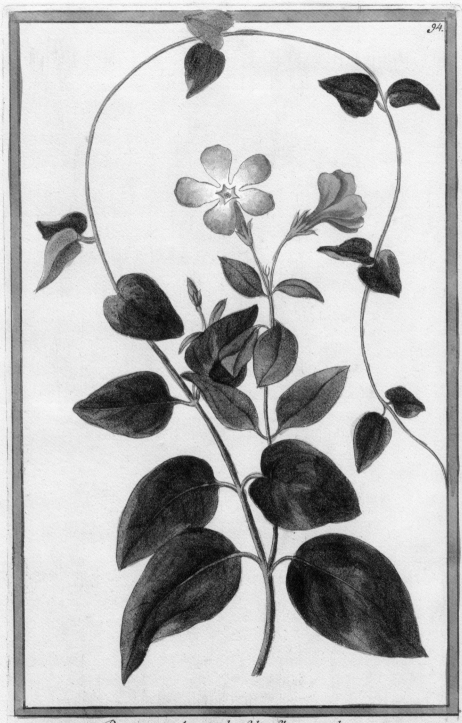

94.

Pervinca vulgaris, latifolia, flore cœruleo. I. R. H. 119.
Ital. Vinca-pervinca. — Gall. Pervenche

36

Roubillac
(French, 1739–about 1820)
Etudes de Fleurs d'après Nature
Paris: n.d. [1780–1800]

Bouquet of Rose, Anemone, Carnation,
Tulip, and Jonquil
Design and engraving by Roubillac
(French, 1739–about 1820)

Pattern books that served as models for the decorative arts industries were an interesting part of the artistic economy in eighteenth-century France—a response to a market for floral motifs in the prevailing Rococo taste of the period. Such practical study books were widely available and provided a source of income for the many talented artists and engravers whose illustrations can be found among their leaves. Working in the decorative tradition of flower painting that continued to dominate in France, Roubillac edited a collection of twenty-three cahiers, or notebooks, each of which included four designs. The notebooks feature bouquets, arrangements in vases, fruits, and sprays of flowers. Roubillac and the French artist Carle were the primary draftsmen (with the one exception of cahier seventeen, which was drawn by Redouté), and Roubillac engraved most of the plates; the rest were engraved by Duruisseau. Most are in the crayon manner and are printed in sanguine, a reddish-brown color that resembles red chalk.

This charming, small bouquet is made up of five types of flowers, each of which is identified: roses, anemones, carnations, tulips, and jonquils. The heavier rose stem, drawn with a burin or etching needle, establishes the center of the composition, and delicately modeled flowers cluster on either side. Like other artists of his time, Roubillac was passionate about drawing, and he learned how to reproduce it with fidelity by mastering the crayon manner of engraving. His skill with that technique is evident in this plate, which perfectly translates the variety of light and crumbly strokes that make up the blossoms.

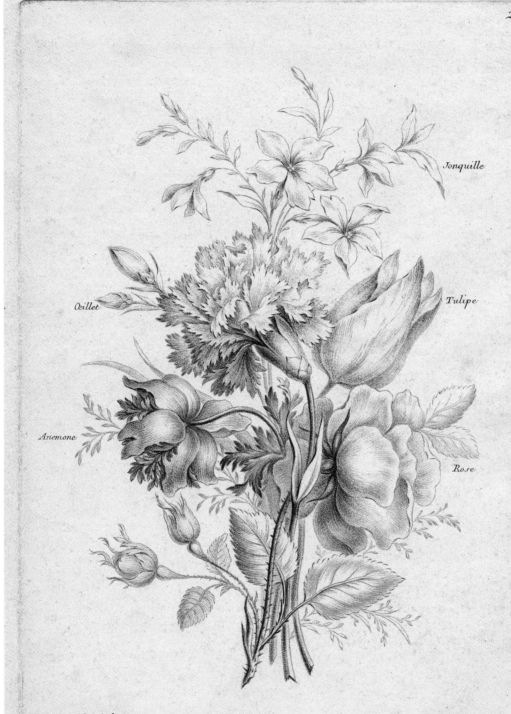

Jonquille

Tulipe

Œillet

Anemone

Rose

Roubillac del et Sculp.

37–39

Pierre-Joseph Buchoz
(French, 1731–1807)
Collection Précieuse et Enluminée des Fleurs les Plus Belles et les Plus Curieuses, Qui se Cultivent Dans les Jardins de la Chine Que Dans Ceux de l'Europe
Paris: 1776

37

Lotus with Frog
Design by unidentified artist
(Chinese, century unknown)
Etching and coloring by unidentified
artist (French, 18th century)

38

Lotus with Duck
Design by unidentified artist
(Chinese, century unknown)
Etching and coloring by unidentified
artist (French, 18th century)

39

Water Plantain
Design by unidentified artist
(Chinese, century unknown)
Etching and coloring by unidentified
artist (French, 18th century)

Born in 1731 in Metz, Pierre-Joseph Buchoz trained as a lawyer and a doctor but found his true calling as a writer and publisher on a wide variety of scientific subjects, most notably medicine, agriculture, ornithology, entomology, and botany. His publications were often compilations of the work of others, yet the sheer volume of his output makes him an important popularizer of natural history. The title of his 1776 publication translates as *A Rare, Illustrated Collection of Flowers Grown in Chinese and European Gardens*.

The book was divided into two sections of one hundred plates each, the first of which was devoted to plants grown in China. While its intention was the portrayal of exotic plants, the volume did not follow contemporary conventions of botanical illustration. No details of specific scientific interest were included, and the work has therefore often been dismissed by botanists, both in Buchoz's time and today. However, such critics seem unaware of the great decorative appeal of the plates. Based on drawings said to have been painted in China by Chinese artists, they introduced a distinctly Asian aesthetic into European botanical illustration. Some included Chinese characters beneath the image, although these seem to have been "drawn," as if copied from a Chinese taxonomy book, rather than written by someone familiar with the language.

Each of the prints, which were made in Paris, was surrounded by a yellow wash border. The flat and somewhat abstract forms bore little relationship to the prevailing Rococo passion for chinoiseries, intricate fantasies of an imaginary Orient created by artists from Watteau to Pillement. Yet Buchoz addressed his work to the same market of decorative arts manufacturers served by the Rococo designers, as well as to painters, florists, and, of course, naturalists. These three studies of aquatic plants share a simplified background, consisting of water and blank sky. The plants dominate the foreground, their heads high above the water. In the two views of the lotus, the lovely flowers are balanced against the weight of sumptuous curved leaves. The inclusion of fauna—an ornately feathered duck painted in fantastic colors, a frog, a crayfish, and a darting insect—was a typical feature of the Chinese designs.

Buchoz went on to publish further works on the botany of Asia, including an herbal of Chinese medicinal plants and, in 1792, an iconography of Japanese flora, the *Herbier Colorié du Japon*.

Pl. XXIII.

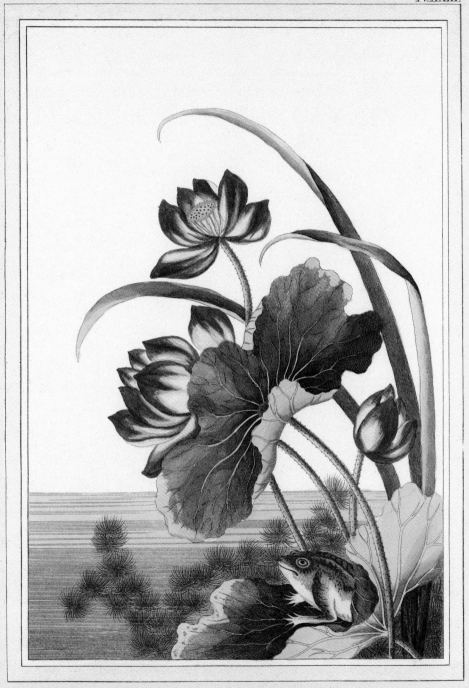

Pl. LXXXII.

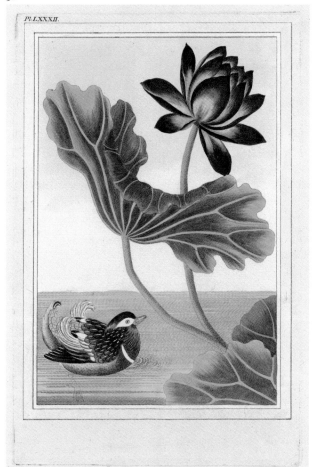

Pl. LXXVIII.

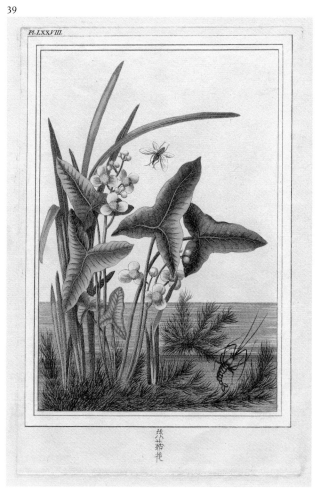

William Curtis
(English, 1746–1799)
Flora Londinensis
London: 1777–98

*A Variety of English Speedwell
(Veronica Becabunga)*
Design by unidentified artist
(English, 18th century)
Engraving and coloring by unidentified
artist (English, 18th century)

William Curtis's *Flora Londinensis* was one of the most beautiful botanical publications to appear in London in the late eighteenth century. In its focus on British plants, it was not unlike John Hill's *British Herbal* of 1756 or John Edwards's 1770 work of the same name. It differed in concept in that whereas Hill and Edwards covered all of Britain, Curtis focused on the common plants growing wild within a ten-mile radius of London, a notion that developed out of his botanizing expeditions in the city's environs. He gradually expanded the geographical area to include plants growing in the south of England as well.

Curtis was an apothecary by training but an entomologist and botanist by predilection. He practiced his profession for a while in London but abandoned it for his true interest in botany. After working for several years at the Chelsea Physic Garden, by then one of the most important botanical collections in the world, he created his own garden, which contained six thousand species and was maintained by subscription memberships.

Flora Londinensis was a deluxe production, for which Curtis engaged the finest artists and engravers. These included the artist-scientist James Sowerby; William Kilburn, a designer in the calico industry; and eventually Sydenham Edwards, whom Curtis had trained in botanical illustration after noticing his natural talent when Edwards was a boy of eleven. A total of 434 plates were issued between 1777 and 1798. Unfortunately, the publication was ultimately not successful. People were generally not interested in gorgeous representations of ordinary plants, and the subscriptions did not pay the costs of its luxury production.

The beautiful life-size illustrations incorporated botanical details such as the reproductive parts of the plant, and accompanying texts provided information about the plant, its scientific and common names, its habitat, and where it had been found. The plate *Veronica Becabunga* uses an unusual horizontal composition that accommodates the spreading habit of the plant. In the simple and graceful design, the trailing roots fall like sheer panels on a gown, while delicate blue flowers are scattered among the leaves. Through such intelligent observation, Curtis's publication leads us to see the beauty in an everyday roadside plant.

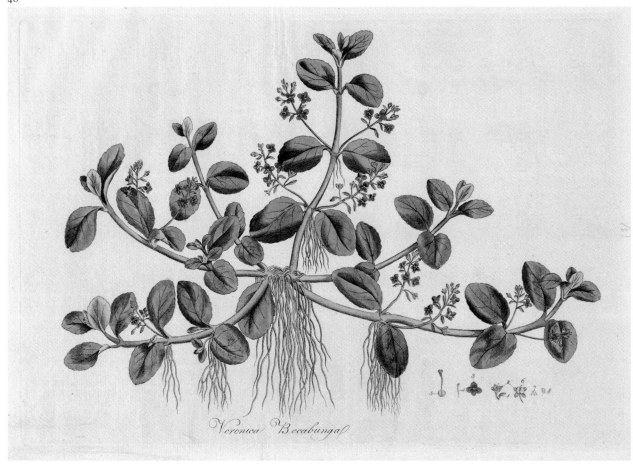

Veronica Becabunga.

Jan van Huysum
(Dutch, 1682–1749)
Richard Earlom
(English, 1742/43–1822)
A Flower Piece and *A Fruit Piece*
London: 1778–81

41

A Flower Piece, 1778
Design by Jan van Huysum
(Dutch, 1682–1749), 1722
Engraving and coloring by Richard
Earlom (English, 1742/43–1822)

42

A Fruit Piece, 1781
Design by Jan van Huysum
(Dutch, 1682–1749), 1723
Engraving and coloring by Richard
Earlom (English, 1742/43–1822)

Richard Earlom's two mezzotint engravings were made after oil canvases painted by Jan van Huysum in 1722 and 1723 that were in the collection of Sir Robert Walpole, the prime minister of England. They indicate how Van Huysum, considered a flower painter without peer in his lifetime, was held in the highest esteem long after his death.

Van Huysum was born into a family of painters in Amsterdam and studied the craft with his father. His brother Jacobus was active as a flower painter in England. Influenced by still-life painters of the previous century, such as Jan Davidsz. de Heem and Willem van Aelst, Jan van Huysum became the torchbearer of the Dutch flower-painting tradition that had developed in Holland in the early years of the seventeenth century. He excelled at sumptuous bouquets painted in an exuberant Baroque style, working from nature with a great attention to detail and a high standard of perfection.

These mezzotints of his paintings were made for John Boydell, a printer and publisher in London who was instrumental in fostering fine engraving in England. Boydell was especially interested in reproducing works by the Old Masters found in English collections. He first employed Earlom, one of the best mezzotint and stipple engravers of the day, in 1774 to make two hundred mezzotints based on the *Liber Veritas*, a book of drawings after Claude Lorrain's landscape paintings. Further projects with Earlom included the prints after Van Huysum's flower paintings. The beautiful result proves how successfully the difficult mezzotint technique, in the hands of a master, could reproduce the textures and tones of a complex composition. The prints enhanced the fame of Earlom and Boydell alike.

Mezzotint engraving was a subtractive process, in which the copperplate was first roughened all over with a special tool so that if it were printed the result would be a velvety black. The artist then burnished out his design, working from dark to light. Earlom's skill and sensitivity is evident in both plates, as he moves from the darkest shadows toward the luminous white flower that is the central point of each composition. He captures a variety of textures—the fuzz of peach skin, the taut plumpness of grapes, the soft depths of flower petals, the cool smoothness of stone carvings—bathing them all in a lambent, moist atmosphere.

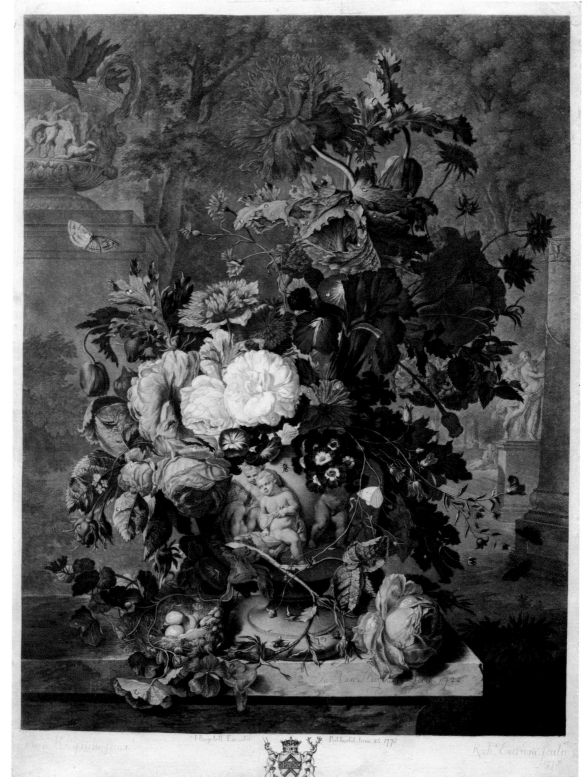

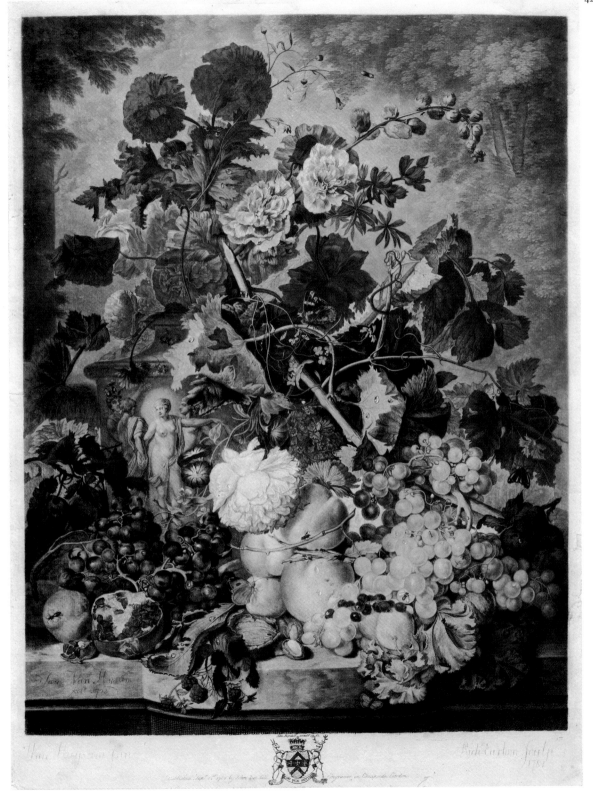

43–47
William Curtis
(English, 1746–1799)
The Botanical Magazine; or Flower Garden Displayed
London: 1787–present

43

Masson's Heath (Erica Massoni), 1796
Design by Sydenham Edwards
(English, 1768–1819)
Etching by Francis Sansom
(English, active 1780s–1810s)
Coloring possibly by William Graves
(English, 18th century)

44

*Plantain-Leaved Thrift
(Statice Speciosa)*, 1803
Design by Sydenham Edwards
(English, 1768–1819)
Etching by Francis Sansom
(English, active 1780s–1810s)
Coloring possibly by William Graves
(English, 18th century)

45

Dingy Flag Iris (Iris Lurida), 1803
Design by Sydenham Edwards
(English, 1768–1819)
Etching by Francis Sansom
(English, active 1780s–1810s)
Coloring possibly by William Graves
(English, 18th century)

Discouraged by the financial difficulties of his *Flora Londinensis* (cat. 40), William Curtis envisioned an entirely new kind of botanical publication: a less expensive, octavo-size periodical that would address a wider audience of "ladies, gentlemen, and gardeners." With this periodical, which he called *The Botanical Magazine*, Curtis presided over a fundamental change in botanical publication and its illustration. His sumptuous, expensive *Flora* had represented the existing model of the eighteenth century and earlier, in which wealthy, often aristocratic, patrons underwrote lavishly illustrated folios; in contrast, *The Botanical Magazine* was adapted to modern times, appealing to a broader base that craved practical knowledge to pursue their passion for horticulture.

The first issue of the magazine appeared in 1787. In it, Curtis merged botanical science and horticulture, combining the contributions of Carl Linnaeus and Philip Miller, the gardener who had brought international fame to the Chelsea Physic Garden. Each issue contained three hand-colored engravings of exotic plants that people wanted in their gardens, accompanied by a scientific description, a history, and cultural information. Curtis provided both the Linnaean and common names and also noted the specific nursery where the illustrated specimen, drawn from the living plant, had been grown.

For the illustrations, Curtis called on the same group of artists who had worked with him on *Flora Londinensis*. His protégé, Sydenham Edwards, produced most of the designs. Edwards stayed with the magazine long after Curtis's death, devoting most of his life to the periodical and contributing 1600 out of 1721 plates in the first twenty-eight years of the publication. William Graves supervised the beautiful hand-coloring by a team of thirty women and children, including Curtis's daughter.

The Botanical Magazine was immediately successful, with circulation reaching three thousand, and is still published today by the Royal Botanic Gardens at Kew. The long life of the publication provides a survey of gardening taste in England over more than two centuries. At the cutting edge of botanical information, it both set trends and tracked them. The Erica pictured here, for instance, reflects the fashion for this plant around 1800. The magazine's high standards in form as well as content persisted throughout its history. Although lithography replaced engraving in 1845, the tradition of hand-colored plates continued until 1948.

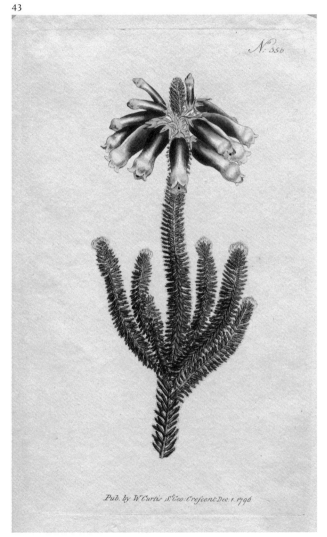

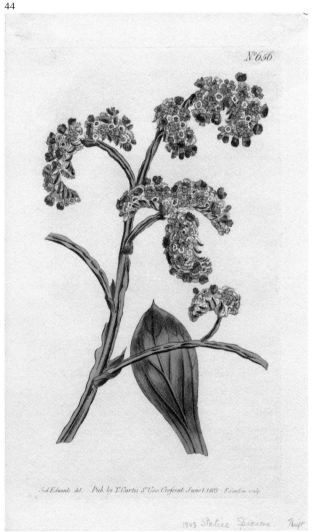

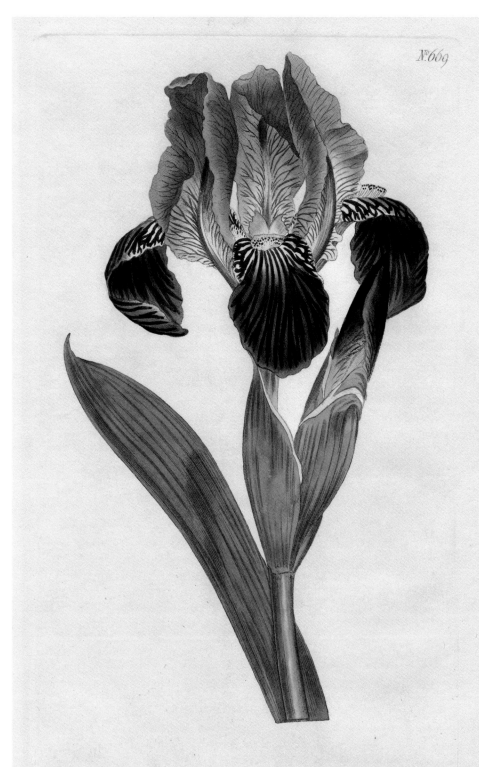

Syd Edwards del. Pub. by Curtis, St Geo. Crescent Aug. 1. 1803. F. Sansom sculp

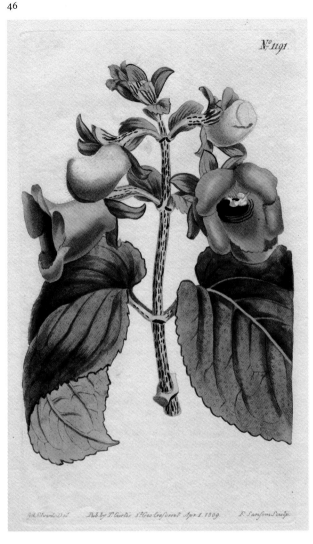

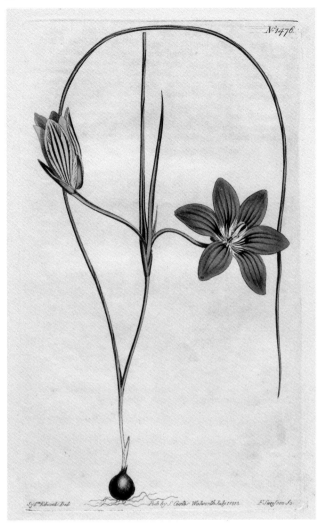

46

*Spotted-Stalked Gloxinia
(Gloxinia Maculata)*, 1809
Design by Sydenham Edwards
(English, 1768–1819)
Etching by Francis Sansom
(English, active 1780s–1810s)
Coloring possibly by William Graves
(English, 18th century)

47

*Crimson Trichonema (Trichonema
Speciosum)*, 1809
Design by Sydenham Edwards
(English, 1768–1819)
Etching by Francis Sansom
(English, active 1780s–1810s)
Coloring possibly by William Graves
(English, 18th century)

Dr. Robert John Thornton
(English, about 1768–1837)
The Temple of Flora
London: 1799–1807

48

The Blue Passion Flower, 1800
Design by Philip Reinagle
(English, 1749–1833)
Engraving and coloring by James
Caldwall (English, 1739–1819)

49

The American Aloe, 1807
Design by Philip Reinagle
(English, 1749–1833)
Engraving and coloring by Thomas
Medland (English, active 1800–1807)

50

Large Flowering Sensitive Plant, 1799
Design by Philip Reinagle
(English, 1749–1833)
Engraving and coloring by Joseph
Constantine Stadler
(English, active 1780–1822)

51

The Dragon Arum, 1801
Design by Peter Charles Henderson
(English, active 1799–1829)
Engraving and coloring by William Ward,
Sr. (English, 1766–1826)

52

The Winged Passion Flower, 1802
Design by Peter Charles Henderson
(English, active 1799–1829)
Engraving and coloring by Warner
(English, active 1800–1810)

The Temple of Flora is one of the most remarkable of all English botanical publications. Although it appeared at the turn of the nineteenth century, in concept it is an eighteenth-century work. The folio is framed in homage to the great Swedish botanist Linnaeus, but it also embodies a summation and praise of the progress of botany during that century.

The project was the creation of Dr. Robert John Thornton. An ardent botanist, Thornton had absorbed the works of Linnaeus and had studied with Thomas Martyn—son of the botanist John Martyn, who had pioneered color printing in his *Historia Plantarum Rariorum* (cat. 14). Thornton's intellectual heritage thus reached back to the century's early innovators. *The Temple of Flora* was part three of his tribute to Linnaeus. A secondary title, *Garden of the Botanist, Poet, Painter and Philosopher*, indicates that Thornton's intent was to set his "picturesque plates" into a broader context of portraits, poetry, and allegorical tributes to Linnaeus and to Nature (Flora) herself. He hired the best artists available to design the lavish work, along with a team of a dozen engravers who used a variety of techniques, including mezzotint, stipple, aquatint, and line engraving. Thirty-two color-printed plates were eventually published, many of them existing in several states. No two copies of the publication are alike.

Thornton's most innovative directive to his artists was to set the plants in their natural habitat, abandoning the convention of a neutral background. The landscapes were only partially accurate, however; romantic imagination prevailed over scientific description, as the artists created exotic corners of the world against which majestic plants towered like kings. As Thornton states in the accompanying text, *The Dragon Arum* (cat. 51), for example, "does not admit of sober description." Rather, the threatening beauty of the plant, gleaming with menace, is set against a volcano under lowering skies.

Unfortunately, the subscriptions for *The Temple of Flora*, which was produced during wartime, were too few to support the costs of its lavish production. Thornton organized a lottery to raise money, but even then he fell short of funds. However, the achievements of this outstanding work speak for themselves. We excuse Thornton his pictorial and textual exaggerations and willingly follow his fantastic ideas beyond scientific accuracy into the realm of philosophy.

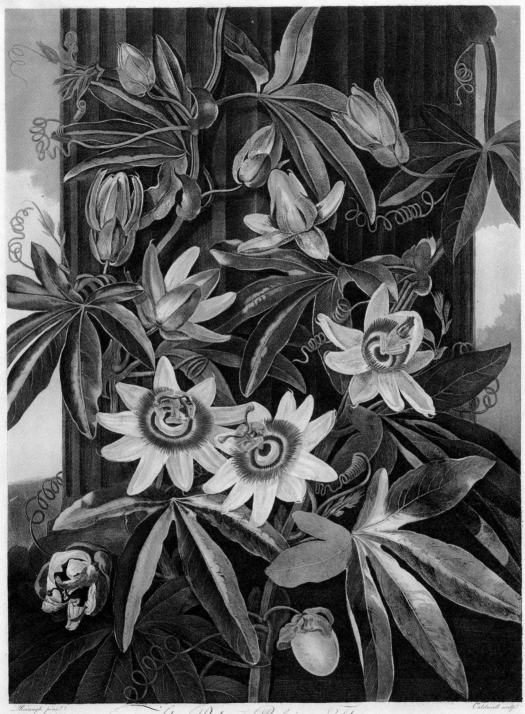

Reinagle pinx.t Caldwall sculp.t

The Blue Passion Flower.

London, Published by D.r Thornton, Jan.y 1800.

49

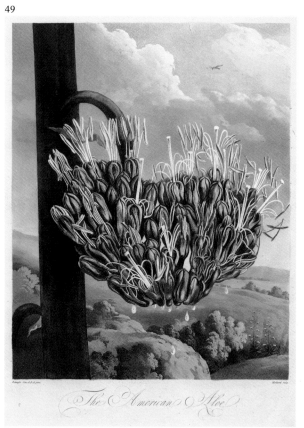

The American Aloe

50

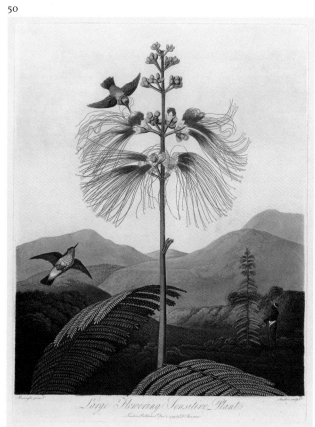

Large Flowering Sensitive Plant

Henderson pinx.

Ward sculp.

The Dragon Arum.

London, Published by D.^r Thornton Dec^r 1. 1801.

The Winged Passion–Flower.

London, Published by Dr. Thornton June 1 1802.

53

The Quadrangular Passion Flower, 1802
Design by Peter Charles Henderson
(English, active 1799–1829)
Engraving and coloring by William
Hopwood (English, active 1800–1803)

54

The American Cowslip, 1801
Design by Peter Charles Henderson
(English, active 1799–1829)
Engraving and coloring by Warner
(English, active 1800–1810)

55

Gerard van Spaendonck
(Dutch, active in France,
1746–1822)
Fleurs Dessinées d'après Nature
Paris: 1799–1801

Double Hyacinth (Hyacinthus orientalis L.)
Design by Gerard van Spaendonck
(Dutch, active in France, 1746–1822)
Engraving by Pierre François Le Grand
(French, 1743–1824)

The Dutchman Gerard van Spaendonck's presence in France transformed botanical illustration in that country. Born in Tilburg, in the Netherlands, he had trained in Antwerp with Guillaume-Jacques Herreyns, a follower of Rubens. Like his brother Cornelis van Spaendonck, director of the Sèvres Porcelain Manufactory, he emerged from the tradition of Dutch flower painting (most vividly exemplified by Jan van Huysum) and brought to his work a lively, unstudied naturalism. Gerard's eventual ascension to important posts in the French botanical painting world effectively merged the two traditions of decorative and scientific illustration.

Van Spaendonck moved to Paris in 1769 and by 1774 was serving as miniature painter to Louis XVI, who had newly acceded to the throne. His abilities were recognized when in 1780 he was appointed professor of flower painting at the Museum of Natural History, a prestigious position held only by the most talented botanical artists. He also excelled as a teacher at the Jardin du Roi, where his talented students—particularly Pierre-Joseph Redouté—formed the nucleus of a brilliant generation of botanical illustrators who brought France to the forefront of this field in the early nineteenth century.

Van Spaendonck's *Fleurs Dessinées d'après Nature* is considered one of the finest models of botanical illustration ever made and is exceedingly rare in early hand-colored impressions. To reproduce his drawings, Van Spaendonck enlisted the services of five different engravers who excelled in their specialized talents of rendering tonal values with stipple or roulette. Their engraving had to describe the form and structure of stems, leaves, and petals but not overpower the watercolor, which was applied by hand to some plates, possibly by Van Spaendonck himself. The resulting images are exceptionally lifelike, conveying both the delicacy of each plant and—in the hand-colored examples—the vibrancy of its color. The monochrome double hyacinth, an engraving with roulette work by Pierre François Le Grand, reveals Van Spaendonck's superb draftsmanship as well as Le Grand's considerable skill in interpreting the artist's hand.

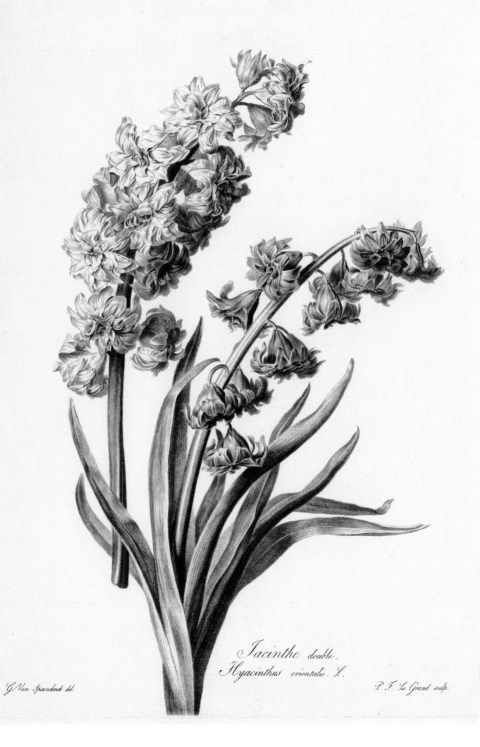

Jacinthe double.
Hyacinthus orientalis. L.

G. Van Spaendonck del.

P. F. Le Grand sculp.

56

Eastern St. John's Wort
Design, etching, and coloring by John
Edwards (English, 1742–1815)

57

Nasturtium
Design, etching, and coloring by John
Edwards (English, 1742–1815)

58

The Indian Reed
Design, etching, and coloring by John
Edwards (English, 1742–1815)

59

Orange Tree
Design, etching, and coloring by John
Edwards (English, 1742–1815)

56–59

John Edwards
(English, 1742–1815)
***A Collection of Flowers Drawn
after Nature and Disposed in an
Ornamental and Picturesque
Manner by J. Edwards FSA***
London: 1801

John Edwards exhibited his paintings of still-life and floral subjects
widely in London. Like many of his contemporaries, he was a member of
the Society of Artists, becoming its president in 1775. Later, he was a
member of the Royal Academy. His love of flowers led him to publish a
botanical work in 1770 titled *The British Herbal*, dedicated to plants that
"blow in the open air of Great Britain," including "useful medical
plants." This book reflected the contemporary interest in native flora.
Edwards and two other artists made the one hundred hand-colored
etchings and engravings after his own designs. Some botanical details
were included, and informative texts gathered from various sources
were appended. A second edition of the *Herbal*, published in 1775,
expanded the focus to include garden flowers and the "exotic," or
foreign, flowers admired by English gardeners.

A *Collection of Flowers Drawn after Nature* appeared thirty years later.
Edwards drew, engraved, and colored the seventy-nine flower studies,
which are sensitive interpretations of the plants rather than botanical
analyses. He printed them in pale gray ink that is scarcely visible beneath
the coloring, making the prints seem like watercolors. Two types of
illustrations are included in the book: Ten plates are delicate ornamental
designs in the Neoclassical style of Robert Adam, characterized by
urns, vases, and architectural elements draped with graceful floral
garlands. The remaining group consists of flower studies, many of them
surrounded by an oval border colored in gray wash, a favorite framing
device of the late eighteenth century. The beautiful design and exquisite
coloring of leaves and blossoms in plates like the *Nasturtium* are evidence
of Edwards's observational skills and talent as a flower painter.

There is no claim of botanical intent for the *Collection*, and no texts
accompany the images. The emphasis of the volume, as the title states, is
on the ornamental and the picturesque. While accurate and naturalistic,
the plates were perhaps designed by Edwards for the calico industry to
which he, and other artists of his time, often provided models.

Eastern St. Johns Herb

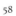

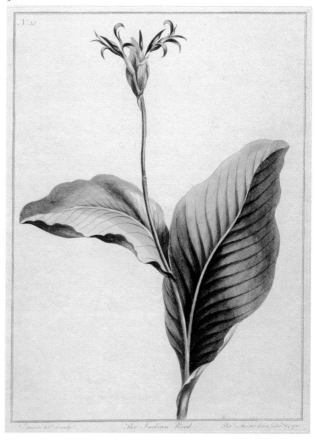

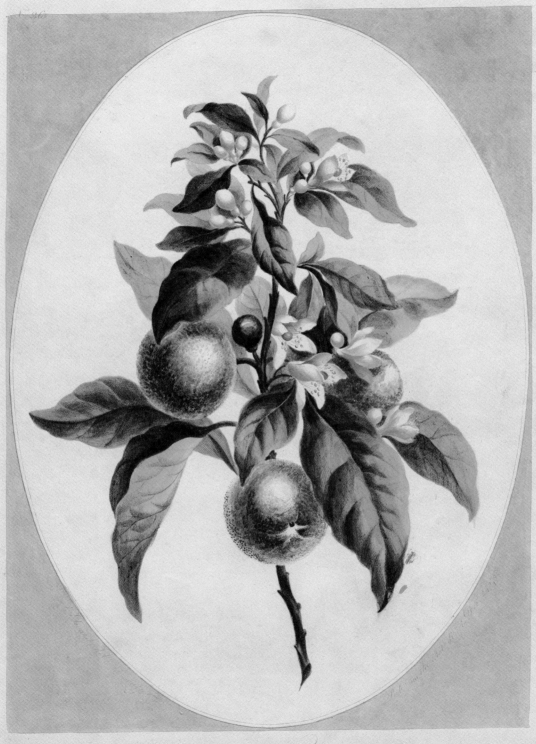

Orange Tree.

60–63
Pierre-Joseph Redouté
(French, born in Flanders,
1759–1840)
Les Liliacées, 8 vols.
Paris: 1802–16

60

Boatlily (Tradescantia Discolor), 1807
Design by Pierre-Joseph Redouté
(French, born in Flanders, 1759–1840)
Engraving and coloring by de Gouy
(French, active 1800–1820)

61

Dalmation Iris (Iris pallida), 1813
Design by Pierre-Joseph Redouté
(French, born in Flanders, 1759–1840)
Engraving and coloring by de Gouy
(French, active 1800–1820)

62

African Cornlily (Ixia Hyalina), 1805
Design by Pierre-Joseph Redouté
(French, born in Flanders, 1759–1840)
Engraving and coloring by Langlois
(French, active 1805–1840)

63

Albuca (Albuca minor), 1802
Design by Pierre-Joseph Redouté
(French, born in Flanders, 1759–1840)
Engraving and coloring by Lemercier
(French, 19th century)

Pierre-Joseph Redouté is perhaps the most celebrated flower painter in Western art, owing to his immensely productive career painting flowers, overseeing the many publications based on his images, and teaching the art of flower painting to high-born pupils. His mastery of botanical drawing, watercolor technique, and stipple engraving were the keys to his success. The beauty of Redouté's art won him royal patronage as the court painter to Marie-Antoinette. By 1798 Josephine, wife of Napoleon Bonaparte, had become his protector. Josephine was passionate about horticulture and collected rare plants from around the world. Advised by botanists, she created magnificent gardens, orangeries, and greenhouses at Malmaison, her château outside of Paris, and she hired Redouté to portray the exotic species she collected there.

Redouté was the sole illustrator of three books based on the Malmaison gardens and an important contributor to others. *Jardin de la Malmaison*, with texts by the botanist and librarian Etienne-Pierre Ventenat, was commissioned by Josephine and appeared during the first years of Redouté's own project, *Les Liliacées*. The beauty, if not the fame, of the two books is comparable. A later work, *Les Roses* (cats. 73–74), came out in 1817 and included many examples from the empress's celebrated rose collection.

Les Liliacées is considered one of the finest achievements of botanical illustration. It contains 486 stipple engravings made after Redouté's Malmaison watercolors. The immense project, which took fourteen years to complete and eventually filled eight volumes, involved the work of eighteen engravers, as well as several botanists who wrote the texts for each plate. Aimed at botanists and naturalists, the book provided life-size, accurate records of plants in the lily family—and, ultimately, the amaryllis, iris, and orchid families, too. These plants did not dry well and thus were unsuitable for traditional herbaria (collections of dried plant specimens classified for study). Redouté's images provided botanically accurate records that were also splendid artistic creations.

The *Dalmation Iris* demonstrates the exquisite, refined work possible with the stipple engraving process, from the delicacy of the coloring to the sumptuous modeling of the forms. The cut flower is laid across a sweep of gray green leaves and is shown in bud, in full bloom, and as a spent blossom. Off to the side, Redouté has quietly added uncolored cross sections of small botanical details.

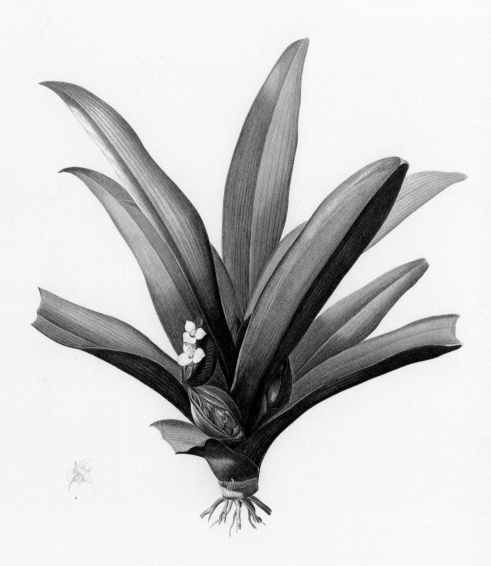

Tradescantia Discolor *Ephemere Discolore*

P. J. Redouté pinx. de Gouy sculp.

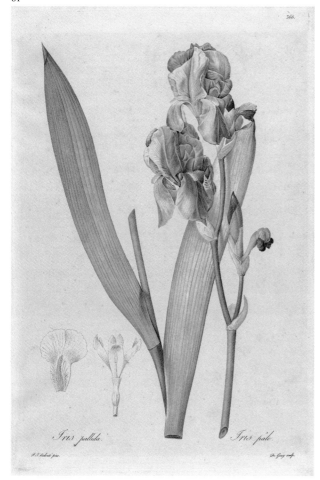

Iris pallida. *Iris pale.*

Ixia Hyalina. *Ixia demi-transparent.*

Albuca Minor. *Albuca Jaunâtre.*

P. J. Redouté pinx. Lemercier sculp. Tessaert direx.

64–65

Pierre-Joseph Redouté
(French, born in Flanders,
1759–1840)
La Botanique de J. J. Rousseau
Paris: 1805

64

Roots (Racines)
Design by Pierre-Joseph Redouté
(French, born in Flanders, 1759–1840)
Engraving by unidentified artist
(French, 18th century)

65

Parts of Flowers (Fleurs composées)
Design by Pierre-Joseph Redouté
(French, born in Flanders, 1759–1840)
Engraving by unidentified artist
(French, 18th century)

Redouté became the favored illustrator of many of the prominent botanists and naturalists of the early nineteenth century, including Lamarck, Cuvier, Ventenat, Michaux, and Candolle. He also worked on several re-editions of works by noted eighteenth-century authors on botany. The botanical writings of the philosopher and social theorist Jean-Jacques Rousseau were among those experiencing renewed interest, and in 1805 *La Botanique de J. J. Rousseau* was published, with sixty-five plates after watercolors by Redouté.

Rousseau's interest in botany as a scientific pastime began around 1762 during a trip to Switzerland, where a botanist friend introduced him to Carl Linnaeus's new system of taxonomy. Botany coincided well with Rousseau's passion for nature in general. He expanded his knowledge of plants through "botanizing expeditions," long rambles on which he explored, collected plant materials, and then organized them in herbaria. Rousseau wrote about the value of botanical studies in his *Reveries of a Solitary Walker*. He also discussed botany in extensive correspondence with the Duchess of Portland, one of the great patrons of the field in England, and in his letters to Mme Madeleine-Catherine de Lessert, a French acquaintance who sought advice on educating her young daughter in the science. Finally, he wrote, but did not complete, a botanical dictionary.

An English edition of Rousseau's letters on botany was published in 1785 by Thomas Martyn. It is possible that Redouté had seen this work, an octavo format with thirty-eight illustrations drawn and engraved by F. P. Nodder, during his stay in England from 1786 to 1788. His splendid folio edition, however, must have brought entirely new insights to the Rousseau correspondence. The stipple engravings in *La Botanique* illustrate a wide variety of plants discussed in Rousseau's writings. The subtle delicacy that the process could achieve is evident in *Racines*. With great simplicity and a subdued palette of greens, brown, and purple-red, Redouté draws attention to three different root systems: a spreading, strawberry-like plant sends out an elaborate skein of roots every few inches; the shoots of another plant rest upon roots that fall like an exquisite veil; and a plump bulb, glowing with health, stands tall on a sturdy, multi-limbed support of vigorous white roots.

64

RACINES.

65

FLEURS COMPOSÉES.

66–67

Jean-Louis Prévost
(French, about 1760–after 1810)
Collection des Fleurs et des Fruits,
Peints d'après Nature par Jean
Louis Prévost
Paris: 1805

66

Bouquet of Yellow and White Roses,
Hyacinths, and Narcissi
Design by Jean-Louis Prévost
(French, about 1760–after 1810)
Engraving and coloring possibly by Louis-
Charles Ruotte (French, 1754–about 1806)

67

Branch of a Double Peach
Design by Jean-Louis Prévost
(French, about 1760–after 1810)
Engraving and coloring by Louis-Charles
Ruotte (French, 1754–about 1806)

Jean-Louis Prévost's career as a painter of flowers and fruit began when he studied with Jean-Jacques Bachelier and, later, with Gerard van Spaendonck. In Van Spaendonck's studio, he joined a talented group of students that included Redouté, Pancrace Bessa, Turpin, and Poiteau. A prolific oil painter, Prévost specialized in still lifes in the Dutch tradition, characterized by abundant bouquets spilling out of urns and baskets and charming details such as bird's nests filled with eggs.

Prévost also worked in watercolor, and he published some of his watercolor studies of bouquets of flowers and groups of fruit as an exquisite set of stipple engravings. The *Collection des Fleurs et des Fruits* comprised a series of forty-eight plates intended to serve as references for the fabric and porcelain industries. The work is a large-scale deluxe version of the simple crayon-manner cahiers that were made for decorative arts manufacturers (see cat. 36).

Published in twelve notebooks of four plates each, the images are early examples of stipple-engraved, color-printed flower and fruit studies and are contemporaneous with Redouté's *Les Liliacées* (cats. 60–63). Their intent is more aesthetic than botanical, but they are nonetheless highly accurate representations. Comparing the works of Redouté and Prévost, we see two artists of nearly equal ability. However, the opportunities and connections that came to Redouté propelled him to worldwide renown, while Prévost remained relatively unknown. Even so, his *Collection des Fleurs et des Fruits* is considered by many to be one of the finest French flower books of the early nineteenth century.

The role of the engraver, Louis-Charles Ruotte, is an acknowledged part of the publication's success. He was a master of the stipple-engraving process and had worked in England with the popularizer of the method, Francesco Bartolozzi. In Prévost's mixed bouquet, the delicacy of the stipple work and coloring is apparent in the yellow rose, whose vibrant, sun-struck color contrasts with its velvety brown interior. In the branch of a peach tree, Ruotte's luminous interpretation of Prévost's drawing captures the perfection of an ephemeral stage in the flowering cycle, when the blossoms are arriving at full blown and the leaf tips are beginning to sprout in a new, young green.

66

A Paris, chez Vilquin, M.d d'Estampes, grande cour du Palais du Tribunal, N° 20.

67

A Paris, chez Vilquin, M.d d'Estampes, grande cour du Palais du Tribunal, N° 20.

The Horticultural Society of London
Transactions of the Horticultural
Society of London
London: 1805–48

Hybrid Amaryllis Regina vittata, 1824
Design by Barbara Cotton
(English, active 1810–1850)
Engraving and coloring by William Say
(English, 1768–1834)

The Horticultural Society of London was founded in 1804 by Sir Joseph Banks, a devoted Maecenas to the world of botany, and John Wedgwood, eldest son of the potter Josiah Wedgwood. Its aims were to collect information on plants and to teach and encourage the practice of horticulture—further evincing the popularity of this pastime and its stimulative effect on botanical publishing during this period.

In 1812 the society hired the botanical painter William Hooker to be its in-house artist, a position he filled until 1820. He had studied with Francis Bauer, the chief artist at Kew and one of the greatest botanical draftsmen of all time. Hooker was a specialist in fruit portraiture; his *Pomona Londinensis* appeared in 1818, six years after George Brookshaw's *Pomona Britannica* (cat. 72). His principal work for the Horticultural Society—in addition to his regular artistic contributions to the *Transactions*, its journal—was his commission to create a ten-volume set of watercolors called *Drawings of Fruit*. After Hooker became ill, other artists—including Barbara Cotton, the designer of this stunning amaryllis study—made the drawings for later volumes in the set.

Barbara Cotton is little known beyond her work for the Horticultural Society. She was one of several women artists, among them Augusta Withers, Sarah Anne Drake, and Lady Broughton, who regularly contributed drawings to the *Transactions*. Botanical illustration was an important outlet for talented, artistic women, an arena in which their work was considered equal to that of their male colleagues. In their hands, the art of painting fruit and flowers became far more than the "useful accomplishment for ladies of leisure" recommended by garden and landscape designer John Loudon in his publication *The Gardener's Magazine*.

Regard for the elegant amaryllis family persisted in the early nineteenth century, from Redouté's *Liliacées* (cats. 60–63) through Priscilla Bury's *Selection of Hexandrian Plants* (cats. 80–81) and beyond. In Barbara Cotton's *Hybrid Amaryllis*, the flowering stalk surges from a grouping of strappy leaves, and the trumpet-shaped flowers are shown from various angles. Their lively red balances the many shades of green in the leaves. Cotton published at least one other amaryllis in the *Transactions*. Many of the works in the collection, including this one, were published as steel engravings. Although this method, introduced in 1820, sometimes produced hard and mechanical-looking images, William Say's aquatint admirably transmits the vibrancy of Cotton's drawing.

HORT. TRANS. VOL. V. PL.

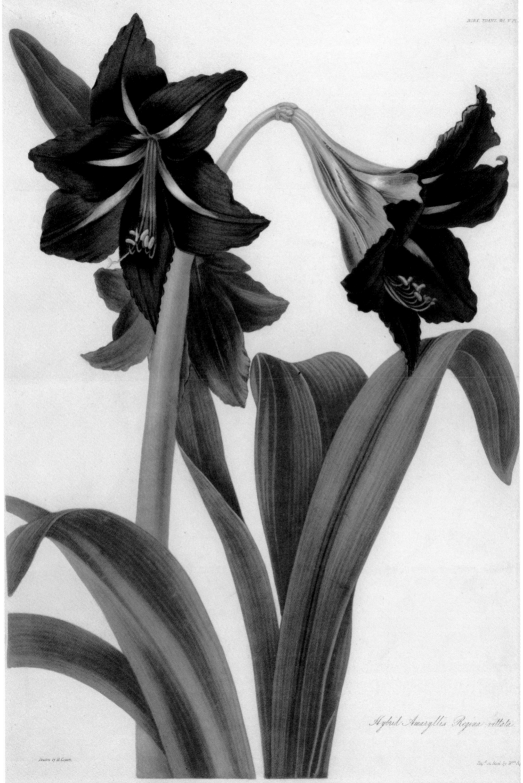

Hybrid Amaryllis Regina vittata.

Drawn by R. Cooper.

Eng.d on Steel by W.m S.

Henry Charles Andrews
(English, active 1794–1830)
Roses; or a Monograph of the Genus Rosa, 2 vols.
London: 1805–28

69

Moss Rose (Rosa muscosa)
Design, etching, and coloring by
Henry Charles Andrews
(English, active 1794–1830)

70

Dwarf Province Rose (Rosa provincialis nana)
Design, etching, and coloring by
Henry Charles Andrews
(English, active 1794–1830)

71

White Province Rose (Rosa provincialis alba)
Design, etching, and coloring by
Henry Charles Andrews
(English, active 1794–1830)

Background information on Henry Charles Andrews is scant, and he is best known by his influential publications, which appeared regularly in the first quarter of the nineteenth century. His periodical *Botanist's Repository*, issued from 1799 to 1811, was the first rival to William Curtis's *Botanical Magazine*. Specializing in newly introduced plants, it must have been an invaluable resource for gardeners interested in being up-to-date on the many exotic species arriving in England, especially from South Africa. Andrews's *Coloured Engravings of Heaths* (1802–29) was the definitive work on the genus *Erica* and, along with his later monograph *The Heathery* (1804), played a key role in the surging popularity of this botanical group. Two other monographs, *Geraniums* and *Roses*, began to come out at about the same time. Andrews was publishing plates for all of these works simultaneously over many years—a feat that is all the more remarkable given that he drew, engraved, and colored the images himself.

The illustrations for *Roses* were drawn directly from the plants, which were grown in local nurseries—a familiar milieu for Andrews, who was married to the daughter of the nurseryman John Kennedy. The descriptions indicated where each plant had been grown. Andrews's work was not a sales catalogue, but it does recall the early eighteenth-century publications of Robert Furber and the Society of Gardeners, which emerged from commercial entities. The best of Andrews's style as both artist and engraver can be seen in this selection of images from the monograph. *Rosa provincialis alba* illustrates a clipped stem of white roses. Two full-blown flowers are shown, one from the front and one from the back, along with tight buds (colored green) and swelling buds (showing a blush of pink). Clusters of leaves are depicted from different sides. The etched lines are quite faint, and the coloring is delicate.

Redouté, whose own work on roses began to appear in 1817, commented that Andrews's illustrations were "far from satisfactory" for a naturalist. But the aims of the two publications were quite different. Working for Empress Josephine from her great collection, Redouté was addressing an audience of sophisticated naturalists. Andrews, meanwhile, addressed a new world of the amateur gardener, for whom his monograph was a perfect guide to the genus *Rosa* and the personalities of its many wonderful varieties.

21/ᵗ - 286

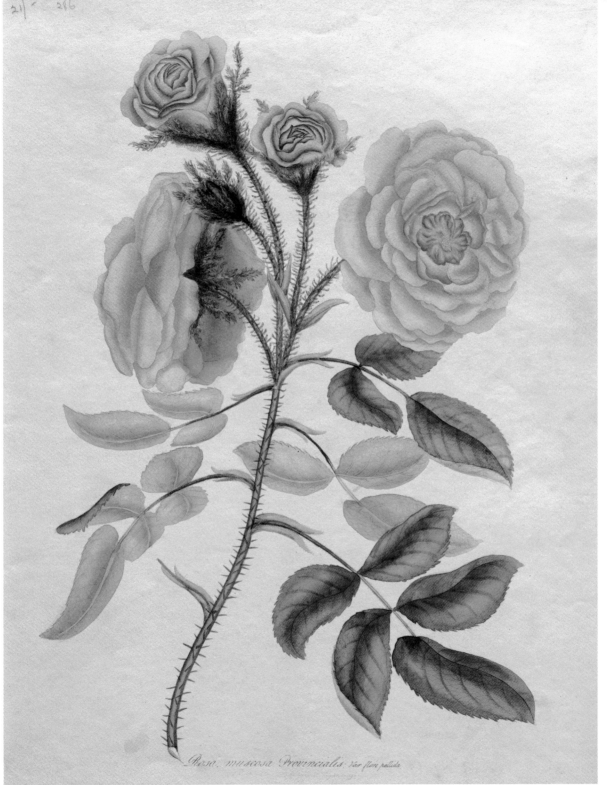

Rosa muscosa Provincialis var flore pallida

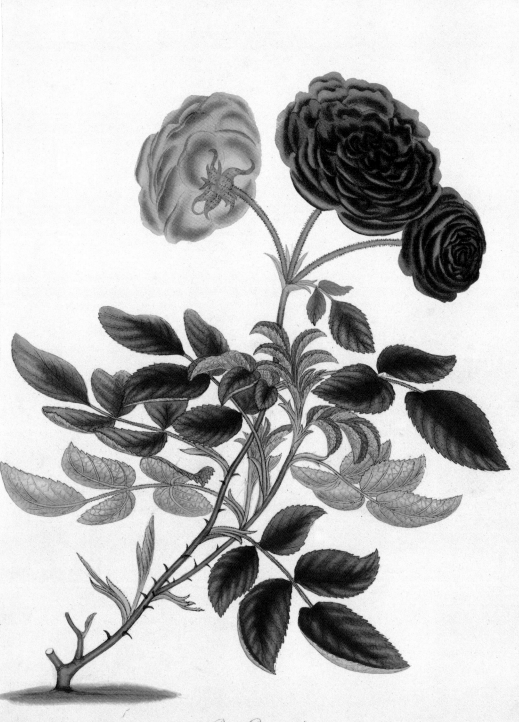

Rosa, Provincialis nana

157° 270

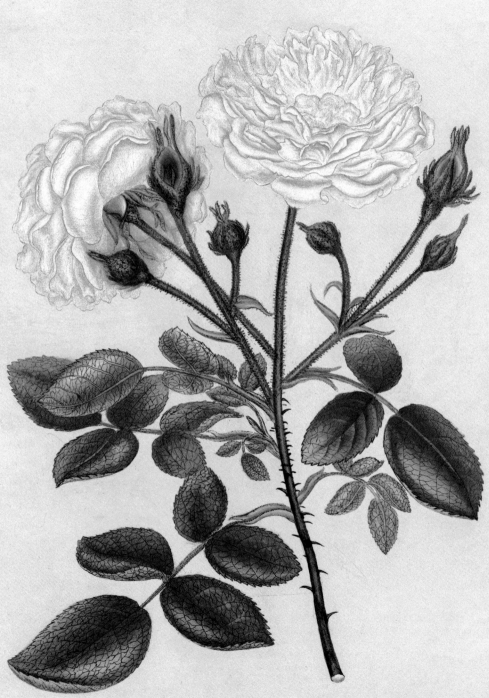

Rosa, Provincialis, alba

White Province

72
George Brookshaw
(English, 1751–1823)
Pomona Britannica
London: 1812

Three Varieties of Cherries, 1807
Design by George Brookshaw
(English, 1751–1823)
Etching and coloring possibly by Richard
Brookshaw (English, 1736–about 1804)

George Brookshaw had a successful first career in the late eighteenth century as a furniture designer, specializing in painted decorations of fruit and flowers. His fashionable clientele included the Prince of Wales. For unknown reasons, he disappeared from view and lived under an assumed name for a decade, only to emerge in 1804 as a botanical illustrator and expert in horticulture. The first plates of his outstanding work *Pomona Britannica*, which was dedicated to George, Prince Regent, were issued in that year. Illustrated with ninety aquatint plates, printed in color, the complete book depicted 256 varieties of fruit grown in the great gardens in and around London, specifically at Hampton Court. These aquatints are held to be among the finest English work of the period.

Brookshaw's aim was both to illustrate the best varieties of fruits to grow, and to indicate which were not worth growing at all. Botany, he stated, had been emphasized at the expense of horticulture, a "vast field of amusement" for those interested in a garden. *Pomona Britannica* thus participated in an anti-botany trend, a movement toward the practical pleasures of growing plants as opposed to their scientific study. However, the lavish and expensive book still took the format of the great botanical books of the previous two centuries, and its audience was the gentleman proprietor of an estate with a gardening staff.

In most of the plates, the richly colored fruits were set off beautifully against a dark aquatint background. It is easy to imagine that the motifs Brookshaw painted on furniture in his earlier career might have inspired this aesthetic choice. In *Three Varieties of Cherries*, he illustrates the Early May, described as small and with poor flavor; the Adam's Crown, a must-have with excellent flavor and abundant fruit; and the beautiful Red Heart, "seldom found in London markets."

A smaller quarto edition of *Pomona Britannica* came out in 1817. Brookshaw also published several well-received drawing manuals, some specialized for flowers, birds, or fruit. These treatises were a response to the popularity of watercolor drawing as a pastime for young women.

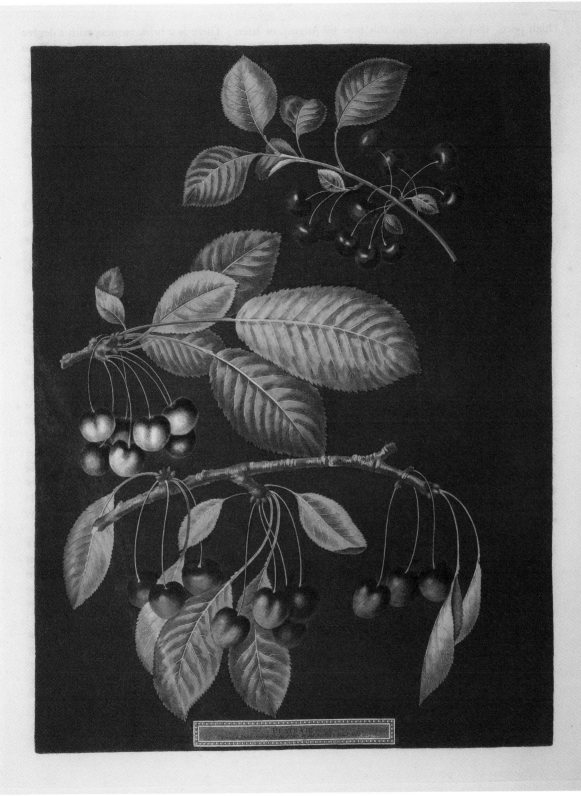

PLATE VII

73–74

Pierre-Joseph Redouté
(French, born in Flanders,
1759–1840)
Les Roses, 3 vols.
Paris: 1817–24

73

*Kamtschatka Rose
(Rosa Kamtschatica)*, 1817
Design by Pierre-Joseph Redouté
(French, born in Flanders, 1759–1840)
Engraving and coloring by Chapuy
(French, 19th century)

74

*White-Flowered Rose
(Rosa Leucantha)*, 1817
Design by Pierre-Joseph Redouté
(French, born in Flanders, 1759–1840)
Engraving and coloring by Chapuy
(French, 19th century)

Les Roses is perhaps the most widely known work by Redouté. Published between 1817 and 1824, it was the next major project he undertook after completing *Les Liliacées* (cats. 60–63) and, like that work, was inspired by the gardens at Malmaison. Empress Josephine's magnificent collection of roses was begun as early as 1804 and included hundreds of species. Although she died in 1815, before the first fascicles of *Les Roses* appeared, the book stands as a tribute to her role as a great patron of botany and botanical art.

Les Roses consists of 168 stipple engravings after Redouté's paintings. A text by the botanist and rosarian Claude Antoine Thory accompanies each plate, detailing the geographical origin of each variety and giving a botanical description and notes on its cultivation. The roses depicted came not only from Malmaison but also from Thory's own garden and other well-known Paris collections. Endlessly inventive, Redouté captured the individuality of each flower without compromising botanical accuracy, although some critics have noted the beginnings of a stylized, more superficial elegance in the work. Despite this criticism, the images and texts of *Les Roses* combine to produce a work of great beauty as well as a valuable scientific record. Many of the flowers pictured were the ancestors of today's roses; others no longer exist.

It is generally believed that in *Les Roses*, the craftsmanship of stipple engraving, printing, and hand-retouching reached a pinnacle of technical perfection. As usual, many different engravers were involved in the production, and the role of these talented engravers in making Redouté's artistic vision available to a wide audience cannot be overemphasized. The extreme delicacy of coloring and modeling in Redouté's original watercolors was translated with such skill that the prints themselves could almost be mistaken for the paintings.

Les Roses was a lavish production to which Redouté was wholly committed, but he no longer had Josephine's generous patronage behind him. In spite of the book's success, it seriously strained his finances. Although the publication was a highpoint in an astounding career and will be forever associated with Redouté's name, it also marks the beginning of the financial difficulties that would overshadow the last twenty years of his life.

73

Rosa Kamtschatica. *Rosier du Kamtschatka.*

P. J. Redouté et pinx. Imprimerie de Remond. Chapuy sculp.

74

Rosa Leucantha. *Rosier à fleurs blanches.*

P. J. Redouté pinx. Imprimerie de Remond. Chapuy sculp.

75–77

Samuel Curtis
(English, 1779–1860)
Monograph on the Genus Camellia
London: 1819

75

Buff, or Humes Blush Camellia / Myrtle-Leaved Camellia
Design by Clara Maria Pope
(English, about 1768–1838)
Etching by Weddell
(English, active 1816–1819)

76

Single White Camellia / Single Red Camellia
Design by Clara Maria Pope
(English, about 1768–1838)
Etching by Weddell
(English, active 1816–1819)

77

Anemone Flower'd, or Waratah Camellia / Rose Color'd, or Middlemists Camellia
Design by Clara Maria Pope
(English, about 1768–1838)
Etching by Weddell
(English, active 1816–1819)

Samuel Curtis's *Monograph on the Genus Camellia* was the first work devoted entirely to that flower and is considered one of the greatest English camellia books. It was published in 1819, participating in and contributing to the popularity of the camellia—a rage that was to last until at least 1870. An exceptionally rare work, the book exists in fewer than ten known copies today.

Curtis, a nurseryman near London who specialized in flowers, was a cousin of William Curtis, founder of *The Botanical Magazine.* He married William's adopted daughter and sole heir after William's death in 1799. Samuel was thus well situated in the world of botanical publishing to undertake his first project in 1806, *The Beauties of Flora*, a work that was designed to compete with Thornton's *Temple of Flora.* With the success of that publication and others like his camellia book, Curtis experienced a steady rise to prominence. By 1820 he was able to purchase a large property in Essex called Glazenwood, where he raised a large variety of fruit trees and established a spectacular garden. In 1827 he became the editor and proprietor of *The Botanical Magazine*, his cousin's immensely successful journal.

Curtis's camellia monograph is illustrated with five large-scale aquatint plates after designs by Clara Maria Pope, one of the most prominent women artists of the period. A former artist's model, Pope achieved a painting career that lasted forty years. She exhibited at the Royal Academy, beginning in the 1790s, and worked in a variety of styles, including miniatures, rustic landscapes, portraiture, and eventually flowers. Her designs for the monograph are of an impressively large size, quite the opposite of miniature paintings. The bouquets make a dramatic impact and often include several varieties, as in these examples. In 1819, when only twenty-nine camellia varieties were known, Pope illustrated eleven of them. The plates after her designs are characterized by the heavy application of gum arabic on the leaves, a glaze that increases the brilliancy and transparency of the colors.

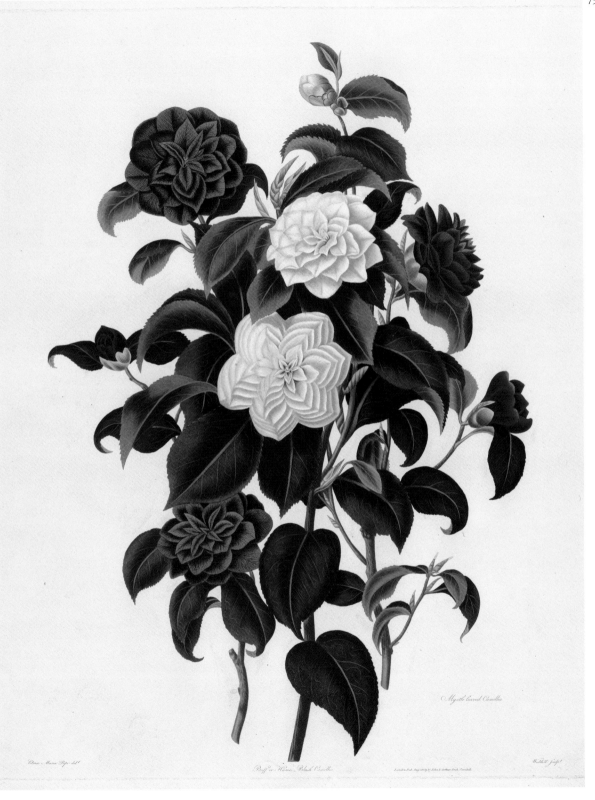

Clara Maria Pope delt.

Buff'or Warrea Blush Camellia.

London Pub. Aug. 1819 by John & Arthur Arch, Cornhill.

Weddell sculp.

Myrtle leaved Camellia

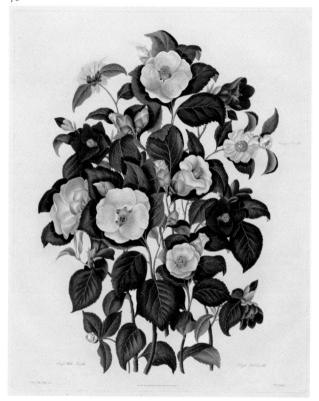

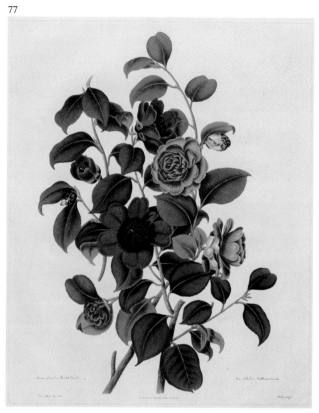

78–79

Pierre-Joseph Redouté
(French, born in Flanders,
1759–1840)
Choix des Plus Belles Fleurs
Paris: 1827–33

78

Poppy (Papaver)
Design by Pierre-Joseph Redouté
(French, born in Flanders, 1759–1840)
Engraving and coloring by Langlois
(French, active 1805–1840)

79

Pomegranate (Grenadier punica)
Design by Pierre-Joseph Redouté
(French, born in Flanders, 1759–1840)
Engraving and coloring by Victor
(French, active 1820–1850)

The *Choix des Plus Belles Fleurs* is the greatest work of Redouté's late period. Published in parts between 1827 and 1833, it consists of 144 stipple engravings of favorite garden flowers, some arranged in bouquets. Sixteen of the plates, such as the *Pomegranate* shown here, depict branches of fruit. In a deviation from Redouté's usual style, butterflies and insects enliven some of the illustrations.

The publication is characterized by its aesthetic elegance. Whereas in earlier works botanical texts gave scientific weight to Redouté's plates, in *Choix des Plus Belles Fleurs* the artist's sharp observation and devoted attention to detail educate the eye to see as a botanist sees. His comments in the preface to the book describe his method as one of "ceaseless observation of nature in its constancy and variety of forms and colors." The *Poppy* shows the extent to which scientific truth can be embodied in the beauty of the illustration: Redouté depicts the underside of the flower, highlighting the extreme delicacy of its coloring, which fades from a purple-blue sheen to pink. The gently dimpled petals are radiant with freshness, and a heavy seedpod nods beside the blossom. In all its narcotic seductiveness, the plant is laid out for study as if newly picked.

The book is dedicated to the princesses Louise and Marie d'Orléans, daughters of King Louis-Philippe, who had studied flower painting with the artist. Even though Redouté's financial circumstances were reduced in his later years, his reputation had not suffered and he continued to enjoy royal patronage through France's changing regimes. He was appointed to the position of master of drawing at the Museum of Natural History, and in 1825 he received the medal of Chevalier of the Legion of Honor on the recommendation of Charles X.

Redouté felt that plant illustration was of value not only for science but for industry as well, since accurate plant studies were necessary to embellish luxury products such as porcelain, textiles, and wallpaper. He taught his students that successful botanical drawing rested upon a foundation of accuracy, composition, and color, mastery of which would guarantee the permanence of Nature's evanescent beauty.

78

Pavot. *Papaver.*

P. J. Redouté. Langlois

79

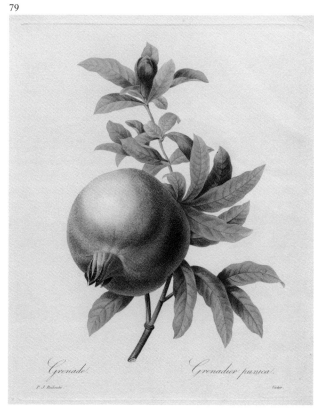

Grenade. *Grenadier punica.*

P. J. Redouté. Victor

Mrs. Edward Bury
(English, 1799–1872)
A Selection of Hexandrian Plants
London: 1831–34

80

*Small Striped Amaryllis
(Amaryllis vittata minor)*
Design by Mrs. Edward Bury
(English, 1799–1872)
Engraving and coloring by Robert Havell,
Jr. (American, born in England,
1793–1878)

81

Crinum Lily (Crinum scabrum)
Design by Mrs. Edward Bury
(English, 1799–1872)
Engraving and coloring by Robert Havell,
Jr. (American, born in England,
1793–1878)

Mrs. Edward Bury (née Priscilla Susan Falkner) was one of the most accomplished botanical artists of the nineteenth century, and her *Selection of Hexandrian Plants* is a great work of botanical illustration. Born in Liverpool to a well-off family, she grew up in a fine home with impressive gardens and greenhouses. Like Maria Sibylla Merian, she was a self-confident and independent woman who followed her own interests. These included both art and botany, which she taught herself.

By 1830 Priscilla Falkner had created a portfolio of watercolors of the lily family that she wished to publish according to the model of William Roscoe's *Monandrian Plants*, of 1828. Roscoe, a leading cultural figure of Liverpool and a botanist among his other accomplishments, had encouraged many women artists in botanical illustration, including his daughter-in-law, Mrs. Edward Roscoe.

The prospectus for Falkner's initial project, to be edited by the natural historian William Swainson, described a collection of lithographs to be published by subscription and printed by Hullmandel, the best lithographic printer of the day. Her marriage to Edward Bury intervened, however, and the work did not appear until 1831, transformed into a collection of fifty-one aquatints engraved by Robert Havell, Jr., who, like Hullmadel, was the best of his métier. At that time, Havell was preparing the prints for John James Audubon's *Birds of America*. His superb work is considered an essential part of the success of Audubon's publication, and the same can be said of the aquatints he made for the new Mrs. Bury.

The scope of Bury's work had expanded to include the amaryllis family as well as lilies, both defined as hexandrian plants because of their six stamens. She aimed to represent each species in its "full dimensions, accurately colored." Her style, in fact, does achieve an effective balance between bold forms and exquisite, delicate coloring. Each plant is approached differently, with some seen in their entirety and others studied in a close-up view.

Bury contributed to other botanical publications, including *Maund's Botanic Garden* and *The Botanist*. Like Anna Atkins before her, she was also a pioneer in scientific photography. Her role as a woman scientific illustrator expanded when, in 1860, she published a work on polycystins (minute and primitive sea organisms found as fossils in Barbados), using photography to reproduce drawings made from her microscope observations.

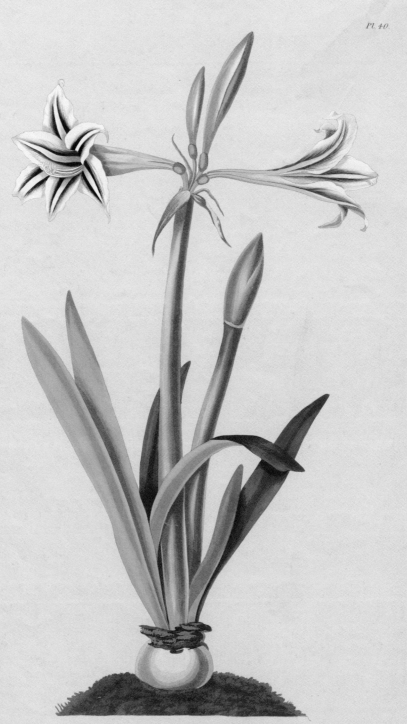

Pl. 40.

Drawn by Mrs E.Bury, Liverpool.

AMARYLLIS VITTATA. Minor

Engraved, Printed,& Coloured, by R. Havell.

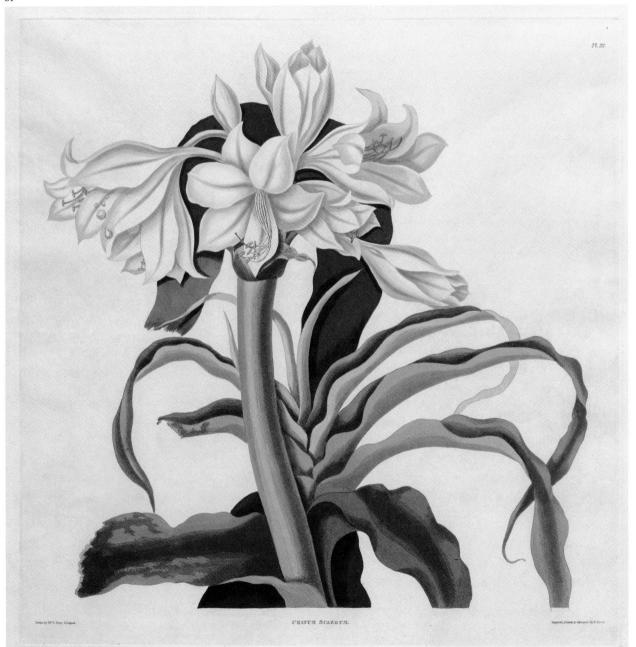

Pl. 32.

Drawn by Mrs E. Bury, Liverpool.

CRINUM SCABRUM.

Engraved, Printed & Coloured, by R. Havell.

Sir Joseph Paxton
(English, 1803–1865)
*The Magazine of Botany, and
Register of Flowering Plants*
London: 1834–49

82

*Wayman's Brugmansia (Brugmansia
Waymaniana)*
Design possibly by Frederick William
Smith (English, 1797–1835)
Aquatint, color printing, and coloring by
unidentified artist (English, 19th century)

83

Exceptional Astelma (Astelma eximium)
Design possibly by Frederick William
Smith (English, 1797–1835)
Aquatint, color printing, and coloring by
unidentified artist (English, 19th century)

84

Changing Camellia (Camellia mutabilis)
Design possibly by Frederick William
Smith (English, 1797–1835)
Aquatint, color printing, and coloring by
unidentified artist (English, 19th century)

Sir Joseph Paxton's *Magazine of Botany* was among the most influential of the many periodicals devoted to horticulture that appeared in the first half of the nineteenth century. It followed in the footsteps of William Curtis's *Botanical Magazine* (cats. 43–47) and Sydenham Edwards's *Botanical Register*, the best of the genre, and had a wide following throughout its history of thirteen volumes. There is no better indication of the growing popularity of horticulture and gardening, or the changing nature of the audience for botanical illustration, than the existence of these magazines aimed at the general gardening public.

Paxton's periodical was published monthly, each issue illustrated with four plates accompanied by plant descriptions and gardening advice. Although most of the plates were lithographs, a variety of print techniques were used, including combinations of etching, engraving, and aquatint. Hand-coloring was the norm. Paxton's stated aim was to foster a love of gardening and provide "portraits of as many new and beautiful flowers as possible." He worked principally with two draftsmen: Samuel Holden and, until his early death in 1835, Frederick William Smith, whose work may be illustrated here. Both artists favored compositions that were bold on the page, with Holden's work in particular characterized by close-up portraits.

Sir Joseph had an important impact on the botanical world of his time. From humble beginnings, he rose to become chief gardener, then estate manager, of Chatsworth House, the country seat of the Duke of Devonshire. A man of many talents and much energy, Paxton was also a landscape designer, engineer, and architect of garden structures of all kinds. His designs for vast glass and steel greenhouses were the model for the revolutionary architecture of his masterpiece, the Crystal Palace in Hyde Park, which was the grand venue for the Great Exhibition of 1851. In addition, Paxton raised and brought to bloom the first English example of Victoria Regia, a fantastic variety of water lily that the American William Sharp would illustrate in a set of chromolithographs in 1854 (cats. 88–93).

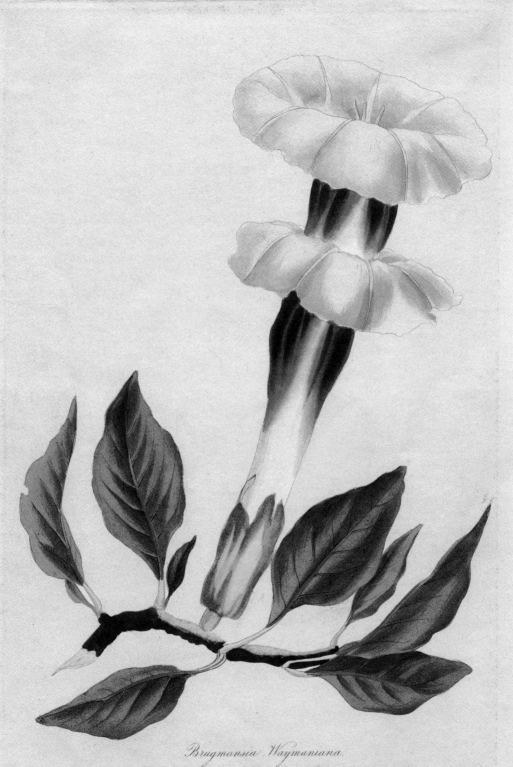

Brugmansia Waymaniana.

83

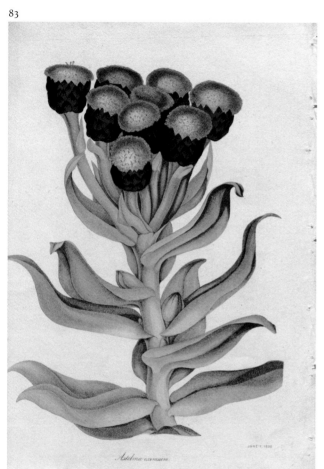

Astelma eximium.

JUNE 1. 1830

84

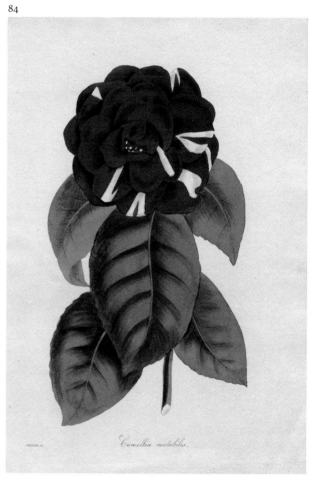

FREDGE, se.

Camellia mutabilis.

85–87

Abbé Laurent Berlèse
(French, 1784–1863)
*Iconographie du Genre
Camellia*, 3 vols.
Paris: 1839–43

85

*Smith's Large-Flowered Camellia (Camellia
Smithii grandiflora)*
Design by Johann Jakob Jung
(German, active 1819–1844)
Engraving by Oudet
(French, 19th century)

86

Apollo Camellia (Camellia apollina)
Design by Johann Jakob Jung
(German, active 1819–1844)
Engraving by Oudet
(French, 19th century)

87

Camellia japonica Imbricata Rubra
Design by Johann Jakob Jung
(German, active 1819–1844)
Engraving by Gabriel
(French, 19th century)

The wealthy botanist Abbé Laurent Berlèse was the leading camellia specialist of the nineteenth century. Although Italian, he lived in Paris, where he assembled a fabulous collection of more than five hundred varieties of the flower in his greenhouses. When Samuel Curtis's *Monograph on the Genus Camellia* (cats. 75–77) was issued in 1819, only twenty-nine varieties were known, of which Clara Maria Pope had depicted eleven. In comparison, Abbé Berlèse's three-volume *Iconographie du Genre Camellia*, published between 1839 and 1843, illustrated three hundred of Berlèse's most beautiful camellias.

The *Iconographie* was the definitive work on the camellia. Johann Jakob Jung made the designs directly from the plants in Berlèse's greenhouses. They are comparable in quality to Redouté's work, demonstrating once again how the technique of stipple engraving contributes to the accuracy and realism of the subject. In fact, the book shows the persistence of stipple engraving well into the period when lithography was the more common method of botanical illustration. The engravings by Dumenil, Gabriel, and Oudet were printed in color by R. Remond of Paris and then finished by hand.

Unlike Pope, who drew lavish mixed bouquets of camellias, Jung painted single flowers with several representative leaves. His compositions show Redouté's ongoing influence, each flower being isolated on a white background and its features carefully scrutinized to disclose its individuality. A more scientific work than Curtis's *Monograph*, Berlèse's *Iconographie* sought to establish a classification system for the many different varieties of camellias based on form. Jung's designs perfectly represented the subtle differences among the varieties and carefully illustrated points made in the accompanying texts, which described culture, growth habits, and abundance of flowers.

Curiously, in 1846 Abbé Berlèse abandoned his fascinating hobby, sold his collection, and returned to Italy. However, horticultural interest in camellias did not wane until the 1870s. The flower was part of the general culture of the time, as well. Alexandre Dumas' *La Dame aux Camélias* and its operatic adaptation, *La Traviata* by Verdi, also celebrated the charm of the camellia.

Pl. 127

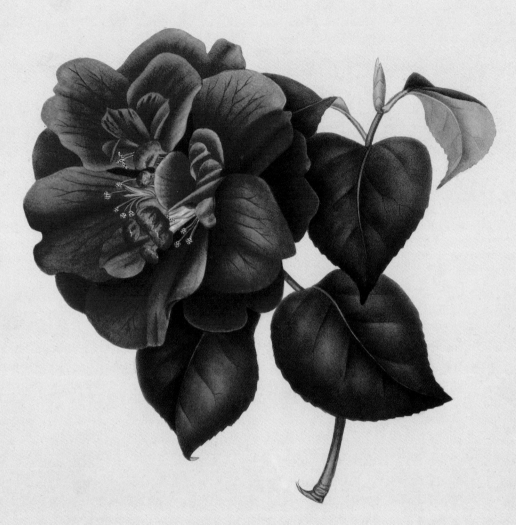

J.J.Jung pinx.

Oudet sc.

Camellia Smithii Grandiflora.

N.Rémond imp.

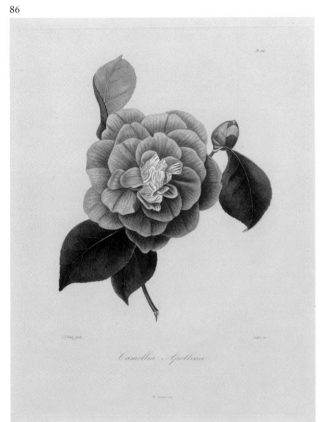

Camellia Apollina

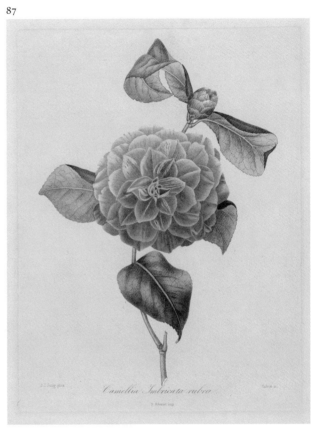

Camellia Imbricata rubra

88–93
John Fisk Allen
(American, 1807–1876)
Victoria Regia
Boston: 1854

88

The First Two Cycles of the Growth of the Lily
Design and chromolithography by
William Sharp (American, born in
England, 1803–1875) after a sketch by
John Fisk Allen (American, 1807–1876)

89

Opening Flower
Design and chromolithography by
William Sharp (American, born in
England, 1803–1875)

90

Underside of the Leaf
Design and chromolithography by
William Sharp (American, born in
England, 1803–1875)

91

Intermediate Stages of Bloom
Design and chromolithography by
William Sharp (American, born in
England, 1803–1875)

92

Complete Bloom
Design and chromolithography by
William Sharp (American, born in
England, 1803–1875)

93

*A Partial Bloom Caused by Low
Temperature*
Design and chromolithography by
William Sharp (American, born in
England, 1803–1875)

The six-plate chromolithographic work *Victoria Regia* is regarded as the foundation of color printing in America. William Sharp, the artist and lithographer, learned his craft in England while working in the shop of Charles Joseph Hullmandel, a key figure in the development of British lithography. Sharp established himself in Boston in the late 1830s and is credited with making the first chromolithographs in the United States. He was well known in horticultural circles by 1847, when the Massachusetts Horticultural Society commissioned him to create designs for a multivolume work called *Fruits of America*. In 1853, in the midst of this project, he was called upon to illustrate this monograph on a botanical phenomenon, the flowering of the Great American Water Lily being raised in nearby Salem by the amateur botanist John Fisk Allen.

In a sequence resembling a time exposure, Sharp made drawings of the flower as it began to open and at subsequent stages right up to full blown. The leaves, which approached six feet in diameter, were considered as important as the flower. With a rim that stood up three to five inches, colored green on the inside and red on the underside, they were like fantastic, floating salvers. Sharp drew the underside, showing the extraordinary thick ribs of the architecture that supported the vast surface expanse. His drawings were made with specific understanding of the painstaking chromolithographic process, an awareness that perhaps accounts for the subtle tonal renditions he achieved. He used four stones to print the plates, carefully aligning the dampened paper on each consecutive stone in the color sequence. The overall delicacy of the colors was a great technical feat, capturing beautiful reflections and transparency in the water.

The completed work approaches Thornton's *Temple of Flora* (cats. 48–54), both in scale and in quality of the color printing; the size of the prints was appropriate to their grand subject. Sharp's images create a sense of peaceful infinity through their large, flat areas of color, a vision of Victoria Regia as it must seem in its natural habitat. In the accompanying text, Allen provided botanical and cultural information. Especially striking is the way that he opened a window onto the world of the plant hunters in the Amazon who discovered the "grandest production of the vegetable world."

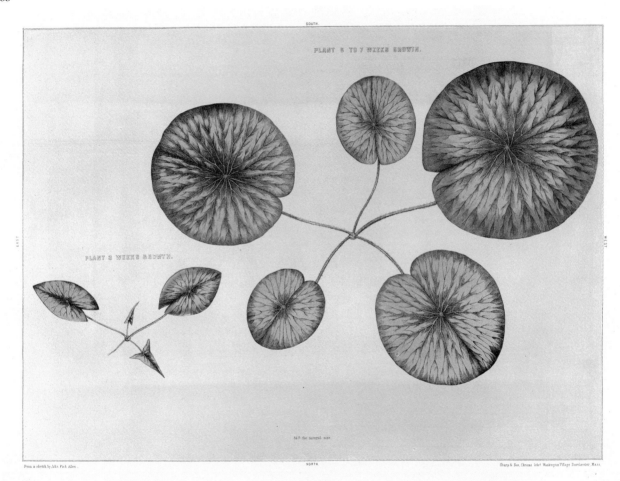

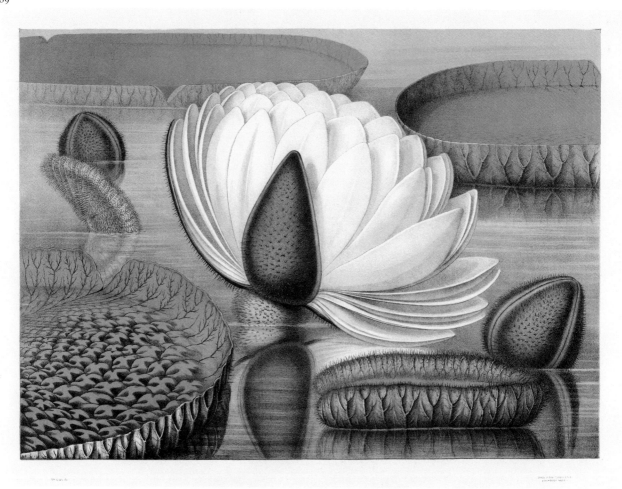

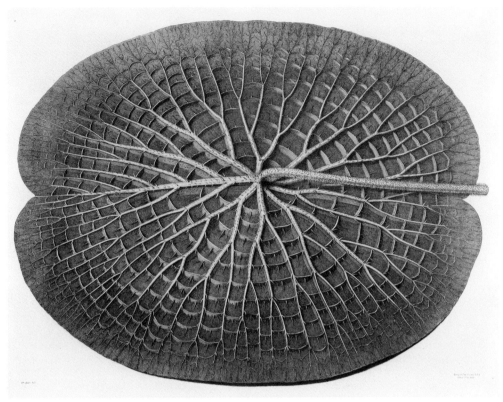

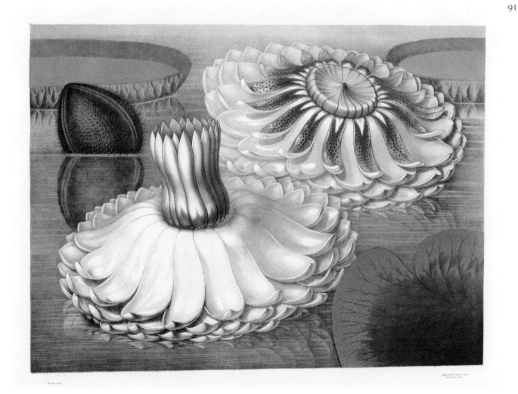

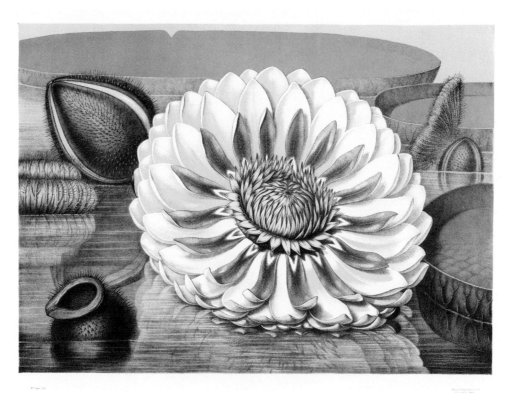

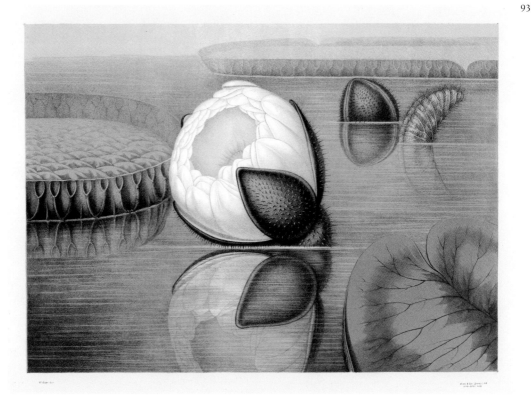

Checklist of Works

The principal sources referred to in this checklist are Gordon Dunthorne, *Flower and Fruit Prints of the 18th and Early 19th Centuries* (1938; New York: Da Capo Press, 1970) and Claus Nissen, *Die Botanische Buchillustration: Ihre Geschichte und Bibliographie*, 2 vols. (Stuttgart: Hiersemann, 1951). The titles of individual works have been translated from the Latin, French, or German when no English title was provided. Where plate and volume numbers are given, they come directly from the print using the terminology found there. All objects are in the collection of the Museum of Fine Arts, Boston.

1–3

Basil Besler (German, 1561–1628)
Hortus Eystettensis
Eichstatt and Nuremberg: 1613; 2nd edition, 1640; 3rd edition, 1713
Illustrated with 367 engravings (sometimes hand-colored)
Nissen 158

1. *Large Sunflower (Flos Solis Maior),* plate 1 from part 5, 1713 edition
Design possibly by Basil Besler (German, 1561–1628)
Engraving by unidentified artist (German, early 17th century)
Coloring by unidentified artist (German, 18th century)
Platemark: 48.5 × 40.3 cm
(19 ⅛ × 15 ⅞ in.)
Bequest of George P. Dike – Elita R. Dike Collection 69.97

2. *Three Varieties of Leucoium (I. Leucoium purpureum variegatum flore pleno. II. Leucoium pleno flore album purpureis maculis signatum. III. Leucoium pleno flore album sanguineis maculis signatum),* plate number and part unknown, 1713 edition
Design possibly by Basil Besler (German, 1561–1628)
Engraving by unidentified artist (German, early 17th century)
Platemark: 48.3 × 40 cm (19 × 15 ¾ in.)
Bequest of George P. Dike – Elita R. Dike Collection 69.360

3. *I. Lady's Slipper. II. Blue Variegated Bearded Iris. III. Dark Variegated Bearded Iris. (I. Calceolus Mariae. II. Iris Portugalica. III. Iris Pannonica variegata),* plate 6 from part [?], 1713 edition
Design possibly by Basil Besler (German, 1561–1628)
Engraving by unidentified artist (German, early 17th century)
Coloring by unidentified artist (German, 18th century)
Platemark: 48.5 × 39.7 cm
(19 ⅛ × 15 ⅝ in.)
Fund in memory of Horatio Greenough Curtis 1970.20

4

Nicolas Robert (French, 1614–1685)
Variae ac Multiformes Florum Species appressae ad Vivum et æneis tabulis incisae
Paris: after 1669
Illustrated with 31 engravings
Nissen 1645

Variegated Tulip / Blue Iris (Tulipa Variegata / Iris Coerulea dod.), plate 24
Design and engraving by Nicolas Robert (French, 1614–1685)
Book, overall: 26.8 × 19.2 × 1.5 cm
(10 ⁹⁄₁₆ × 7 ⁷⁄₁₆ × ⁹⁄₁₆ in.)
Ellen Page Hall Fund 34.852

5–7

Jean-Baptiste Monnoyer (French, 1634–1699)
Livre de Toutes Sortes de Fleurs d'après Nature: Les Vases Diaphanes
Paris: 1660–80
Illustrated with 8 hand-colored engravings and etchings (sometimes uncolored)
Dunthorne 212, Nissen 1399

5. *Arrangement of Roses, Jonquils, and Campanula in a Glass Vase*
Design and etching by Jean-Baptiste Monnoyer (French, 1634–1699)
Sheet, trimmed within platemark: 28 × 21.5 cm (11 × 8 ⁷⁄₁₆ in.)
Maria Antoinette Evans Fund
30.1331.8

6. *Arrangement of Roses, Jonquils, and Campanula in a Glass Vase*
Design, etching, and coloring by Jean-Baptiste Monnoyer (French, 1634–1699)
Platemark: 28.4 × 21.3 cm
(11 ³⁄₁₆ × 8 ⅜ in.)
Bequest of George P. Dike – Elita R. Dike Collection 69.250

7. *Tulips and Hyacinths in a Glass Vase*
Design and etching by Jean-Baptiste Monnoyer (French, 1634–1699)
Sheet, trimmed within platemark: 28 × 20.8 cm (11 × 8 ³⁄₁₆ in.)
Maria Antoinette Evans Fund
30.1331.2

8–9

Abraham Munting (Dutch, 1626–1683)
Naauwkeurige Beschryving der Aardgewassen
Leyden and Utrecht: 1696
Illustrated with 243 hand-colored engravings
Nissen 1428

8. *Chimney Bellflower (Campanula Pyramidalis minor)*, fig. 123, fol. 437
Design by unidentified artist (Dutch, 17th century)
Engraving and coloring by unidentified artist (Dutch, 17th century)
Platemark: 31.8 × 20.7 cm (12 ½ × 8 ⅛ in.)
Bequest of George P. Dike – Elita R. Dike Collection 69.100

9. *Indian Morning Glory (Convolvulus Indicus pennatus)*, fig. 138, fol. 505
Design by unidentified artist (Dutch, 17th century)
Engraving and coloring by unidentified artist (Dutch, 17th century)
Platemark: 31.8 × 25 cm (15 ½ × 9 ¹³⁄₁₆ in.)
Bequest of George P. Dike – Elita R. Dike Collection 69.101

10–11

Maria Sibylla Merian (German, 1647–1717)
Metamorphosis Insectorum Surinamensium
Amsterdam: 1705
Illustrated with 60 hand-colored or uncolored etchings
Dunthorne 205, Nissen 1341

10. *Watermelon with Caterpillar and Moth*, plate 15
Design by Maria Sibylla Merian (German, 1647–1717)
Etching and coloring by Pieter Sluyter (Dutch, 1675–about 1713)
Platemark: 36.7 × 26.2 cm (14 ⁷⁄₁₆ × 10 ⁵⁄₁₆ in.)
Bequest of George P. Dike – Elita R. Dike Collection 69.243

11. *Apple of Sodom (Pomme de Sodome)*, plate 27
Design by Maria Sibylla Merian (German, 1647–1717)
Etching and coloring by Pieter Sluyter (Dutch, 1675–about 1713)
Platemark: 35.3 × 24 cm (13 ⅞ × 9 ⁷⁄₁₆ in.)
Bequest of George P. Dike – Elita R. Dike Collection 69.244

12–13

Johann Christoph Volckamer (German, 1644–1720)
Nürnbergische Hesperides, 2 vols.
Nuremberg: 1708
Illustrated with 247 engravings, sometimes hand-colored
Dunthorne 323, Nissen 2076

12. *Triple-Flowered Egyptian Datura (Datura Aegyptia: Flore triplici seu pleno)*, page 232a
Design by Paul Decker (German, 1677–1713)
Engraving and coloring by unidentified artist (German, 18th century)
Platemark: 31.2 × 20.2 cm (12 ⁵⁄₁₆ × 7 ¹⁵⁄₁₆ in.)
Fund in memory of Horatio Greenough Curtis 1970.16

13. *Indian Phaseolus (Phaseolus Indic: cochleatus)*, page 430
Design by Paul Decker (German, 1677–1713)
Engraving and coloring by unidentified artist (German, 18th century)
Platemark: 31.3 × 20.5 cm (12 ⁵⁄₁₆ × 8 ⅛ in.)
Fund in memory of Horatio Greenough Curtis 1970.17

14

John Martyn (English, 1699–1768)
Historia Plantarum Rariorum
London: 1728
Illustrated with 50 engravings, printed in color and hand-colored
Dunthorne 193, Nissen 1289

Maryland Wild Senna (Cassia Marilandica pinnis foliorum oblongis, calyce floris reflexo), decas III, plate 21
Design by Jacobus van Huysum (Dutch, active in England, 1687/89–1740)
Engraving and color printing by Elisha Kirkall (English, about 1682–1742)
Book, overall: 56.1 × 39 × 3 cm (22 ¹⁄₁₆ × 15 ⅜ × 1 ³⁄₁₆ in.)
Gift of Sylvester Rosa Koehler KBR1350

15–17

Johann Wilhelm Weinmann (German, 1683–1741)
Phytanthoza Iconographia, 4 vols.
Ratisbon: 1737–45
Illustrated with 1025 plates of more than 4000 line engravings and mezzotints, printed in color and hand-colored
Dunthorne 327, Nissen 2126

15. *Bamboo*, n. 226
Design by unidentified artist (German, 18th century)
Etching, engraving, and coloring by Bartolomaüs Seuter (German, 1678–1754)
Platemark: 31.8 × 21 cm (12 ½ × 8 ¼ in.)
Bequest of George P. Dike – Elita R. Dike Collection 69.325

16. *Three Varieties of Turk's Cap Lilies (a. Lilium Martagon Imperiale moschatum / b. Lilium Martagon angustifolium rubrum / c. Lilium Martagon purpureo sanguineum flore reflexo)*, n. 659
Design by unidentified artist (German, 18th century)
Etching, engraving, and coloring by Bartolomaüs Seuter (German, 1678–1754)
Platemark: 33 × 22 cm (13 × 8 ¹¹⁄₁₆ in.)
Bequest of George P. Dike – Elita R. Dike Collection 69.326

17. *Four Varieties of Marigolds (a. Tagetes Indica maxima flore pleno fistuloso/ b. Tagetes Indica major flore simplici fistuloso/ c. Tagetes seu flos Africanus major flore pleno aureo/ d. Tagetes Indica major flore aureo simplici)*, n. 961
Design by unidentified artist (German, 18th century)
Etching, engraving, and coloring by Bartolomaüs Seuter (German, 1678–1754)
Platemark: 33 × 21 cm (13 × 8 ¼ in.)
Bequest of George P. Dike – Elita R. Dike Collection 69.327

18–20

Georg Dionysius Ehret
(German, 1708–1770)

Plantae et Papiliones Rariores Depictae et Aeri Incisa a Georgio Dionysio Ehret

London: 1748–59
Illustrated with 15 hand-colored etchings and engravings
Dunthorne 109, Nissen 583

18. *Martynia and Scotch Broom (1. Martynia annua, villosa et viscosa, folio subrotundo, flore magno rubro. 2. Martynia annua, villosa et viscosa, Auris folio albo tubo longissimo. 3. Cytisus procumbens Americanus flore luteo ramosissimus qui Anil supeditat apud Barbadensium Colones)*, tab. I
Design, etching, engraving, and coloring by Georg Dionysus Ehret
(German, 1708–1770)
Platemark: 42.2 × 27.5 cm
(16 ⅝ × 10 ¹³⁄₁₆ in.)
Bequest of George P. Dike – Elita R. Dike Collection 69.182

19. *Small Climbing Cactus (Cereus minimus scandens polygonus)*, tab. II
Design, etching, engraving, and coloring by Georg Dionysus Ehret
(German, 1708–1770)
Platemark: 42 × 27 cm (16 × 10 ⅝ in.)
Bequest of George P. Dike – Elita R. Dike Collection 69.183

20. *I. Papaya / II. Chickweed / III. Millet Grass (I. Papaya / II. Anagallis / III. Gramen Panicum)*, tab. III
Design, etching, engraving, and coloring by Georg Dionysus Ehret
(German, 1708–1770)
Platemark: 49 × 33.7 cm
(19 ⁵⁄₁₆ × 13 ¼ in.)
Bequest of George P. Dike – Elita R. Dike Collection 69.184

21–22

Georg Wolfgang Knorr
(German, 1705–1761)

Thesaurus Rei Herbariae Hortensisque Universalis, 2 vols.
Nuremberg: 1750–72
Illustrated with 403 hand-colored etchings and engravings
Dunthorne 172, Nissen 1081

21. *Reddish Balsam Apple (Momor dicapomis angulatis, tuberculatis, foliis glabris patenti patinatis. Lin. H. C.)*, plate B3
Design, engraving, and coloring by Georg Wolfgang Knorr
(German, 1705–1761)
Platemark: 30.6 × 19.6 cm
(12 ¹⁄₁₆ × 7 ¹¹⁄₁₆ in.)
Bequest of George P. Dike – Elita R. Dike Collection 69.229

22. *Single-Flowered Red Peony (Paeonia flore simplici rubro)*, plate R3
Design, engraving, and coloring by Georg Wolfgang Knorr
(German, 1705–1761)
Platemark: 30.8 × 19.8 cm
(12 ⅛ × 7 ¹³⁄₁₆ in.)
Bequest of George P. Dike – Elita R. Dike Collection 69.230

23–25

Christoph Jacob Trew
(German, 1695–1769)

Plantae Selectae
Nuremberg: 1750–73
Illustrated with 100 hand-colored engravings
Dunthorne 309, Nissen 1997

23. *Thorny-Leaved Bromelia (Bromelia foliis aculeatis)*, tab. I
Design by Georg Dionysius Ehret
(German, 1708–1770)
Engraving and coloring by J. J. Haid or J. E. Haid (German, 18th century)
Platemark: 38.7 × 28.5 cm
(15 ¼ × 11 ¼ in.)
Bequest of George P. Dike – Elita R. Dike Collection 69.185

24. *Long-Leaved Magnolia (Magnolia foliis ovato oblongis)*, tab. LXI
Design by Georg Dionysius Ehret
(German, 1708–1770)
Engraving and coloring by J. J. Haid or J. E. Haid (German, 18th century)
Platemark: 46.3 × 29.7 cm
(18 ¼ × 11 ¹¹⁄₁₆ in.)
Bequest of George P. Dike – Elita R. Dike Collection 69.186

25. *Papaya (Fructu oblongo melonis effigie)*, tab. VII
Design by Georg Dionysius Ehret
(German, 1708–1770)
Engraving and coloring by J. J. Haid or J. E. Haid (German, 18th century)
Platemark: 43 × 28.6 cm
(16 ¹⁵⁄₁₆ × 11 ¼ in.)
Bequest of George P. Dike – Elita R. Dike Collection 69.187

26–30

Christoph Jacob Trew
(German, 1695–1769)

Hortus Nitidissimis omnem per annum superbiens floribus, sive amoenissimorum florum imagines, 3 vols.
Nuremberg: 1750–92
Illustrated with 188 hand-colored engravings
Dunthorne 310, Nissen 1995

26. *Anemone II (Bisard d'Angleterre)*, plate 20, 1750–66
Design by Georg Dionysius Ehret
(German, 1708–1770)
Engraving and coloring by J. M. Seligmann (German, 1720–1762)
Platemark: 27.7 × 22.3 cm (10 ⅞ × 8 ¾ in.)
Bequest of George P. Dike – Elita R. Dike Collection 69.190

27. *Rosa V, Large Provincial Rose (Rosa Provincialis major)*, plate 46, 1764
Design by Georg Dionysius Ehret
(German, 1708–1770)
Engraving and coloring by Adam Ludwig Wirsing
(German, 1733/34–1797)
Platemark: 28.7 × 22.5 cm
(11 ⁵⁄₁₆ × 8 ⅞ in.)
Bequest of George P. Dike – Elita R. Dike Collection 69.191

28. *Tulipa V, Double White-Edged Tulip (Double blanc bordé)*, plate 22, 1750–66
Design by August Wilhelm Sievert
(German, active about 1750–1760)
Engraving and coloring by Adam Ludwig Wirsing
(German, 1733/34–1797)
Platemark: 41.4 × 23.3 cm
(16 ¹⁵⁄₁₆ × 9 ³⁄₁₆ in.)
Bequest of George P. Dike – Elita R. Dike Collection 69.328

29. *Auricula III*, plate 73, 1769
Design by Johann Karell (German,
active 1760–1780)
Engraving and coloring by Adam
Ludwig Wirsing
(German, 1733/34–1797)
Platemark: 26.7 × 21.6 cm
(10 ½ × 8 ½ in.)
Bequest of George P. Dike – Elita R.
Dike Collection 69.353

30. *Iris Anglica I, Queen Esther
(Königin Esther)*, plate 49, 1764
Design by I. I. Meyer
(German, 18th century)
Engraving and coloring by Adam
Ludwig Wirsing
(German, 1733/34–1797)
Platemark: 43.2 × 21 cm (17 × 8 ¼ in.)
Bequest of George P. Dike – Elita R.
Dike Collection 69.354

31
John Hill (English, 1706–1775)
Exotic Botany
London: 1759
Illustrated with 35 hand-colored
engravings
Dunthorne 131, Nissen 879

Double Crimson Hibiscus, plate 25
Design by John Hill
(English, 1706–1775)
Engraving and coloring by unidentified
artist (English, 18th century)
Platemark: 37 × 23.2 cm (14 %₁₆ × 9 ⅛ in.)
Bequest of George P. Dike – Elita R.
Dike Collection 69.213

32–35
Giorgio Bonelli (Italian, 1742–1782)
Hortus Romanus, 8 vols.
Rome: 1772–93
Illustrated with 800 hand-colored
engravings, etchings, and some
stipple engravings
Dunthorne 45, Nissen 200

32. *Prickly Acanthus (Acanthus
aculeatus)*, t. III, tab. 14
Design by Cesare Ubertini (Italian,
active 18th century)
Engraving and coloring by Magdalena
Bouchard (Italian, active 18th century)

Platemark: 37 × 23 cm (14 %₁₆ × 9 ₁/₁₆ in.)
Bequest of George P. Dike – Elita R.
Dike Collection 69.119

33. *African Geranium (Geranium
Affricanum)*, t. V, tab. 22
Design by Cesare Ubertini
(Italian, active 18th century)
Engraving and coloring by Magdalena
Bouchard (Italian, active 18th century)
Platemark: 35.8 × 21.4 cm (14 ⅛ × 8 ₇/₁₆ in.)
Bequest of George P. Dike – Elita R.
Dike Collection 69.121

34. *Pink-Flowering Rush (Butomus flore
roseo)*, t. V, tab. 25
Design by Cesare Ubertini
(Italian, active 18th century)
Engraving and coloring by Magdalena
Bouchard (Italian, active 18th century)
Platemark: 37.2 × 22.5 cm (14 ⅝ × 8 ⅞ in.)
Bequest of George P. Dike – Elita R.
Dike Collection 69.122

35. *Common Periwinkle (Pervinca
vulgaris)* t. [?], tab. 94
Design by Cesare Ubertini
(Italian, active 18th century)
Engraving and coloring by Magdalena
Bouchard (Italian, active 18th century)
Platemark: 36.4 × 22.5 cm
(14 ⁵/₁₆ × 8 ⅞ in.)
Bequest of George P. Dike – Elita R.
Dike Collection 69.125

36
Roubillac (French, 1739–about 1820)
Etudes de Fleurs d'après Nature
Paris: n.d. [1780–1800]
Illustrated with 92 crayon manner and
line engravings, printed in sanguine
Dunthorne 268, Nissen 1686

*Bouquet of Rose, Anemone, Carnation,
Tulip, and Jonquil*, cahier II
Design and engraving by Roubillac
(French, 1739–about 1820)
Platemark: 31.5 × 22.2 cm (12 ⅜ × 8 ¾ in.)
Bequest of George P. Dike – Elita R.
Dike Collection 69.320

37–39
Pierre-Joseph Buchoz (French, 1731–1807)
**Collection Précieuse et Enluminée des
Fleurs les Plus Belles et les Plus Curieuses,
Qui se Cultivent Dans les Jardins de la
Chine Que Dans Ceux de l'Europe**
Paris: 1776
Illustrated with 200 hand-colored etchings
Dunthorne 60, Nissen 282

37. *Lotus with Frog*, plate XXIII
Design by unidentified artist
(Chinese, century unknown)
Etching and coloring by unidentified
artist (French, 18th century)
Platemark: 32.2 × 21 cm (12 ¹¹/₁₆ × 8 ¼ in.)
Bequest of George P. Dike – Elita R.
Dike Collection 69.104

38. *Lotus with Duck*, plate LXXXII
Design by unidentified artist
(Chinese, century unknown)
Etching and coloring by unidentified
artist (French, 18th century)
Platemark: 32 × 21 cm (12 ⅜ × 8 ¼ in.)
Bequest of George P. Dike – Elita R.
Dike Collection 69.106

39. *Water Plantain*, plate LXXVIII
Design by unidentified artist
(Chinese, century unknown)
Etching and coloring by unidentified
artist (French, 18th century)
Platemark: 32 × 21 cm (12 ⅜ × 8 ¼ in.)
Bequest of George P. Dike – Elita R.
Dike Collection 69.103

40
William Curtis (English, 1746–1799)
**Flora Londinensis; or Plates and
Descriptions of Such Plants as Grow Wild
in the Environs of London**
London: 1777–98
Illustrated with 434 hand-colored
engravings
Dunthorne 87, Nissen 439

*A Variety of English Speedwell
(Veronica Becabunga)*
Design by unidentified artist
(English, 18th century)
Engraving and coloring by unidentified
artist (English, 18th century)
Platemark: 23.5 × 34.2 cm (9 ¼ × 13 ₇/₁₆ in.)
Bequest of George P. Dike – Elita R.
Dike Collection 69.102

41–42

Jan van Huysum (Dutch, 1682–1749)
Richard Earlom (English, 1742/43–1822)
A Flower Piece and *A Fruit Piece*
London: 1778–81
Two hand-colored mezzotints
Dunthorne 313

41. *A Flower Piece*, 1778
Design by Jan van Huysum
(Dutch, 1682–1749), 1722
Engraving and coloring by Richard
Earlom (English, 1742/43–1822)
Sheet, trimmed within platemark:
54.8 × 41 cm (21 9/16 × 16 1/8 in.)
Bequest of George P. Dike – Elita R.
Dike Collection 69.218

42. *A Fruit Piece*, 1781
Design by Jan van Huysum
(Dutch, 1682–1749), 1723
Engraving and coloring by Richard
Earlom (English, 1742/43–1822)
Sheet, trimmed within platemark:
54.3 × 41.2 cm (21 3/8 × 16 1/4 in.)
Bequest of George P. Dike – Elita R.
Dike Collection 69.217

43–47

William Curtis (English, 1746–1799)
*The Botanical Magazine; or Flower Garden
Displayed*
London: 1787–present
Illustrated with hand-colored etchings
Dunthorne 88, Nissen 2350

43. *Masson's Heath (Erica Massoni)*,
no. 356, 1796
Design by Sydenham Edwards
(English, 1768–1819)
Etching by Francis Sansom
(English, active 1780s–1810s)
Coloring possibly by William Graves
(English, 18th century)
Platemark: 20.5 × 11.5 cm
(8 1/16 × 4 1/2 in.)
Bequest of George P. Dike – Elita R.
Dike Collection 69.172

44. *Plantain-Leaved Thrift (Statice
Speciosa)*, no. 656, 1803
Design by Sydenham Edwards
(English, 1768–1819)
Etching by Francis Sansom
(English, active 1780s–1810s)
Coloring possibly by William Graves

(English, 18th century)
Platemark: 20 × 12 cm (7 7/8 × 4 3/4 in.)
Bequest of George P. Dike – Elita R.
Dike Collection 69.175

45. *Dingy Flag Iris (Iris Lurida)*, no. 669,
1803
Design by Sydenham Edwards
(English, 1768–1819)
Etching by Francis Sansom
(English, active 1780s–1810s)
Coloring possibly by William Graves
(English, 18th century)
Platemark: 20 × 12 cm (7 7/8 × 4 3/4 in.)
Bequest of George P. Dike – Elita R.
Dike Collection 69.176

46. *Spotted-Stalked Gloxinia (Gloxinia
Maculata)*, no. 1191, 1809
Design by Sydenham Edwards
(English, 1768–1819)
Etching by Francis Sansom
(English, active 1780s–1810s)
Coloring possibly by William Graves
(English, 18th century)
Platemark: 19.5 × 11.3 cm (7 11/16 × 4 7/16 in.)
Bequest of George P. Dike – Elita R.
Dike Collection 69.177

47. *Crimson Trichonema (Trichonema
Speciosum)*, no. 1476, 1809
Design by Sydenham Edwards
(English, 1768–1819)
Etching by Francis Sansom
(English, active 1780s–1810s)
Coloring possibly by William Graves
(English, 18th century)
Platemark: 20.2 × 12 cm (7 15/16 × 4 3/4 in.)
Bequest of George P. Dike – Elita R.
Dike Collection 69.179

48–54

Dr. Robert John Thornton
(English, about 1768–1837)
*The Temple of Flora; or Garden of Nature.
Picturesque Botanical Plates of the New
Illustration of the Sexual System of
Linnaeus*
London: 1799–1807
Illustrated with 32 aquatint, mezzotint,
stipple and line-engraved plates, printed
in color and finished by hand
Dunthorne 301, Nissen 1955

48. *The Blue Passion Flower*,
plate 17, 1800
Design by Philip Reinagle
(English, 1749–1833)
Engraving and coloring by James
Caldwall (English, 1739–1819)
Platemark: 51 × 38 cm (20 1/16 × 14 5/16 in.)
Bequest of George P. Dike – Elita R.
Dike Collection 69.308

49. *The American Aloe*, plate 12, 1807
Design by Philip Reinagle
(English, 1749–1833)
Engraving and coloring by Thomas
Medland (English, active 1800–1807)
Platemark: 56.3 × 44.7 cm
(22 3/16 × 17 5/8 in.)
Bequest of George P. Dike – Elita R.
Dike Collection 69.313

50. *Large Flowering Sensitive Plant*,
plate 16, 1799
Design by Philip Reinagle
(English, 1749–1833)
Engraving and coloring by Joseph
Constantine Stadler
(English, active 1780–1822)
Platemark: 47.9 × 36.2 cm (18 7/8 × 14 1/4 in.)
Bequest of George P. Dike – Elita R.
Dike Collection 69.314

51. *The Dragon Arum*, plate 22, 1801
Design by Peter Charles Henderson
(English, active 1799–1829)
Engraving and coloring by William
Ward, Sr. (English, 1766–1826)
Platemark: 47.5 × 35 cm (18 11/16 × 13 3/4 in.)
Bequest of George P. Dike – Elita R.
Dike Collection 69.207

52. *The Winged Passion Flower*,
plate 18, 1802
Design by Peter Charles Henderson
(English, active 1799–1829)
Engraving and coloring by Warner
(English, active 1800–1810)
Platemark: 56.5 × 45.7 cm (22 1/4 × 18 in.)
Bequest of George P. Dike – Elita R.
Dike Collection 69.209

53. *The Quadrangular Passion Flower*, plate 19, 1802
Design by Peter Charles Henderson (English, active 1799–1829)
Engraving and coloring by William Hopwood (English, active 1800–1803)
Platemark: 54.7 × 41 cm (21 %₆ × 16 ⅛ in.)
Fund in memory of Horatio Greenough Curtis 1970.21

54. *The American Cowslip*, plate 26, 1801
Design by Peter Charles Henderson (English, active 1799–1829)
Engraving and coloring by Warner (English, active 1800–1810)
Platemark, trimmed at right: 53 × 43.4 cm (20 ⅞ × 17 ¹⁄₁₆ in.)
Bequest of George P. Dike – Elita R. Dike Collection 69.208

55
Gerard van Spaendonck (Dutch, active in France, 1746–1822)
Fleurs Dessinées d'après Nature
Paris: 1799–1801
Illustrated with 24 hand-colored and occasionally color-printed stipple engravings
Dunthorne 314, Nissen 1879

Double Hyacinth (Hyacinthus orientalis L.)
Design by Gerard van Spaendonck (Dutch, active in France, 1746–1822)
Engraving by Pierre François Le Grand (French, 1743–1824)
Platemark: 50.1 × 33.8 cm (19 ¾ × 13 ⁵⁄₁₆ in.)
Eleanor A. Sayre Fund 2009.327

56–59
John Edwards (English, 1742–1815)
A Collection of Flowers Drawn after Nature and Disposed in an Ornamental and Picturesque Manner by J. Edwards FSA
London: 1801
Illustrated with 77 hand-colored etchings
Dunthorne 105, Nissen 579

56. *Eastern St. John's Wort*, no. 53
Design, etching, and coloring by John Edwards (English, 1742–1815)
Platemark: 35 × 26 cm (13 ¼ × 10 ¼ in.)
Bequest of George P. Dike – Elita R. Dike Collection 69.159

57. *Nasturtium*, no. 26
Design, etching, and coloring by John Edwards (English, 1742–1815)
Platemark: 33.8 × 25 cm (13 ⁵⁄₁₆ × 9 ¹³⁄₁₆ in.)
Bequest of George P. Dike – Elita R. Dike Collection 69.155

58. *The Indian Reed*, no. 35
Design, etching, and coloring by John Edwards (English, 1742–1815)
Platemark: 34 × 25 cm (13 ⅜ × 9 ¹³⁄₁₆ in.)
Bequest of George P. Dike – Elita R. Dike Collection 69.156

59. *Orange Tree*, no. 36
Design, etching, and coloring by John Edwards (English, 1742–1815)
Platemark: 35 × 25 cm (13 ¾ × 9 ¹³⁄₁₆ in.)
Bequest of George P. Dike – Elita R. Dike Collection 69.157

60–63
Pierre-Joseph Redouté (French, born in Flanders, 1759–1840)
Les Liliacées, 8 vols.
Paris: 1802–16
Illustrated with 486 stipple engravings, printed in color and finished by hand
Dunthorne 231, Nissen 1597

60. *Boatlily (Tradescantia Discolor)*, plate 168, vol. 3, 1807
Design by Pierre-Joseph Redouté (French, born in Flanders, 1759–1840)
Engraving and coloring by de Gouy (French, active 1800–1820)
Platemark: 52.5 × 35 cm (20 ¾ × 13 ⅞ in.)
Bequest of George P. Dike – Elita R. Dike Collection 69.272

61. *Dalmatian Iris (Iris pallida)*, plate 366, vol. 7, 1813
Design by Pierre-Joseph Redouté (French, born in Flanders, 1759–1840)
Engraving and coloring by de Gouy (French, active 1800–1820)
Platemark: 51.1 × 34.6 cm (20 ⅛ × 13 ⅝ in.)
Bequest of George P. Dike – Elita R. Dike Collection 69.273

62. *African Cornlily (Ixia Hyalina)*, plate 87, vol. 2, 1805
Design by Pierre-Joseph Redouté (French, born in Flanders, 1759–1840)
Engraving and coloring by Langlois (French, active 1805–1840)
Platemark: 53 × 35 cm (20 ⅞ × 13 ¾ in.)
Bequest of George P. Dike – Elita R. Dike Collection 69.276

63. *Albuca (Albuca minor)*, plate 21, vol. 1, 1802
Design by Pierre-Joseph Redouté (French, born in Flanders, 1759–1840)
Engraving and coloring by Lemercier (French, 19th century)
Platemark: 53.4 × 35.5 cm (21 ¹⁄₁₆ × 14 in.)
Gift of Stephen Borkowski in honor of Dominique H. Vasseur 2007.794

64–65
Pierre-Joseph Redouté (French, born in Flanders, 1759–1840)
La Botanique de J. J. Rousseau
Paris: 1805
Illustrated with 65 stipple engravings, printed in color and finished by hand
Dunthorne 252, Nissen 1688

64. *Roots (Racines)*, plate 47
Design by Pierre-Joseph Redouté (French, born in Flanders, 1759–1840)
Engraving by unidentified artist (French, 18th century)
Sheet: 36 × 25.6 cm (14 ¹³⁄₁₆ × 10 ¹⁄₁₆ in.)
Bequest of George P. Dike – Elita R. Dike Collection 69.304

65. *Parts of Flowers (Fleurs composées)*, plate 58
Design by Pierre-Joseph Redouté (French, born in Flanders, 1759–1840)
Engraving by unidentified artist (French, 18th century)
Platemark: 35.8 × 25.7 cm (14 × 10 in.)
Bequest of George P. Dike – Elita R. Dike Collection 69.305

66–67

Jean-Louis Prévost
(French, about 1760–after 1810)
Collection des Fleurs et des Fruits, Peints d'après Nature par Jean-Louis Prévost
Paris: 1805
Illustrated with 48 stipple engravings printed in color
Dunthorne 229, Nissen 1568

66. *Bouquet of Yellow and White Roses, Hyacinths, and Narcissi*, plate 16, IVe livraison
Design by Jean-Louis Prévost (French, about 1760–after 1810)
Engraving and coloring possibly by Louis-Charles Ruotte
(French, 1754–about 1806)
Sheet, trimmed within platemark: 49 × 32 cm (19 ⁵⁄₁₆ × 12 ⅝ in.)
Bequest of George P. Dike – Elita R. Dike Collection 69.264

67. *Branch of a Double Peach*, plate 17, Ve livraison
Design by Jean-Louis Prévost (French, about 1760–after 1810)
Engraving and coloring by Louis-Charles Ruotte
(French, 1754–about 1806)
Platemark: 49.5 × 32 cm (19 ½ × 12 ⅝ in.)
Bequest of George P. Dike – Elita R. Dike Collection 69.265

68

The Horticultural Society of London
Transactions of the Horticultural Society of London, 10 vols. (vols. I to VII; and 2nd series, vols. I to III)
London: 1805–48
Illustrated with 92 hand-colored stipple, aquatint, and steel engravings
Dunthorne 142, Nissen 2387

Hybrid Amaryllis Regina vittata, plate I, vol. V, 1824
Design by Barbara Cotton (English, active 1810–1850)
Engraving and coloring by William Say (English, 1768–1834)
Platemark: 42.2 × 28.2 cm (16 ¾ × 11 ¹³⁄₁₆ in.)
Bequest of George P. Dike – Elita R. Dike Collection 69.136

69–71

Henry Charles Andrews
(English, active 1794–1830)
Roses; or a Monograph of the Genus Rosa, 2 vols.
London: 1805–28
Illustrated with 129 hand-colored etchings
Dunthorne 12, Nissen 34

69. *Moss Rose (Rosa muscosa)*
Design, etching, and coloring by Henry Charles Andrews
(English, active 1794–1830)
Sheet: 29 × 22.6 cm (11 ⁷⁄₁₆ × 8 ⅞ in.)
Bequest of George P. Dike – Elita R. Dike Collection 69.87

70. *Dwarf Province Rose (Rosa provincialis nana)*
Design, etching, and coloring by Henry Charles Andrews
(English, active 1794–1830)
Sheet: 28.8 × 22 cm (11 ⁵⁄₁₆ × 8 ¹¹⁄₁₆ in.)
Bequest of George P. Dike – Elita R. Dike Collection 69.89

71. *White Province Rose (Rosa provincialis alba)*
Design, etching, and coloring by Henry Charles Andrews
(English, active 1794–1830)
Sheet, trimmed within platemark: 29 × 22.8 cm (11 ⁷⁄₁₆ × 9 in.)
Bequest of George P. Dike – Elita R. Dike Collection 69.94

72

George Brookshaw (English, 1751–1823)
Pomona Britannica
London: 1812
Illustrated book with 90 aquatints, printed in color and hand-colored
Dunthorne 50, Nissen 244

Three Varieties of Cherries, plate VIII, 1807
Design by George Brookshaw (English, 1751–1823)
Etching and coloring possibly by Richard Brookshaw
(English, 1736–about 1804)
Book, overall: 59.1 × 48.3 × 5.1 cm (23 ¼ × 19 × 2 in.)
Jessie and Sigmund Katz Collection 1988.527

73–74

Pierre-Joseph Redouté
(French, born in Flanders, 1759–1840)
Les Roses, 3 vols.
Paris: 1817–24
Illustrated with 168 stipple engravings, printed in color and finished by hand
Dunthorne 232, Nissen 1599

73. *Kamtschatka Rose (Rosa Kamtschatica)*, 1817
Design by Pierre-Joseph Redouté (French, born in Flanders, 1759–1840)
Engraving and coloring by Chapuy (French, 19th century)
Platemark: 34.7 × 26 cm (13 ¹¹⁄₁₆ × 10 ¼ in.)
Bequest of George P. Dike – Elita R. Dike Collection 69.286

74. *White-Flowered Rose (Rosa Leucantha)*, 1817
Design by Pierre-Joseph Redouté (French, born in Flanders, 1759–1840)
Engraving and coloring by Chapuy (French, 19th century)
Platemark: 34.6 × 26 cm (13 ⅜ × 10 ¼ in.)
Gift of Stephen Borkowski in memory of Wilfrid J. Michaud, Jr. 2007.792

75–77

Samuel Curtis (English, 1779–1860)
Monograph on the Genus Camellia. The Whole from Original Drawings by Clara Maria Pope
London: 1819
Illustrated with 5 hand-colored aquatints
Dunthorne 85, Nissen 437

75. *Buff, or Humes Blush Camellia / Myrtle-Leaved Camellia*
Design by Clara Maria Pope (English, about 1768–1838)
Etching by Weddell (English, active 1816–1819)
Platemark: 57.5 × 46.8 cm (22 ⅝ × 18 ⁷⁄₁₆ in.)
Bequest of Katharine Lane Weems 1989.656a

76. *Single White Camellia / Single Red Camellia*
Design by Clara Maria Pope (English, about 1768–1838)
Etching by Weddell (English, active 1816–1819)

Platemark: 57.8 × 46.6 cm
(22 ¾ × 18 ⅜ in.)
Bequest of Katharine Lane Weems
1989.656b

77. *Anemone Flower'd, or Waratah Camellia / Rose Color'd, or Middlemists Camellia*
Design by Clara Maria Pope
(English, about 1768–1838)
Etching by Weddell
(English, active 1816–1819)
Platemark: 58.1 × 46.8 cm (22 ⅞ × 18 ⁷⁄₁₆ in.)
Bequest of Katharine Lane Weems
1989.656e

78–79
Pierre-Joseph Redouté
(French, born in Flanders, 1759–1840)
Choix des Plus Belles Fleurs
Paris: 1827–33
Illustrated with 144 stipple engravings, printed in color and finished by hand
Dunthorne 235, Nissen 1591

78. *Poppy (Papaver)*
Design by Pierre-Joseph Redouté
(French, born in Flanders, 1759–1840)
Engraving and coloring by Langlois
(French, active 1805–1840)
Platemark: 27.3 × 21.6 cm (10 ¾ × 8 ½ in.)
Fund in memory of Horatio Greenough Curtis 1970.18

79. *Pomegranate (Grenadier punica)*
Design by Pierre-Joseph Redouté
(French, born in Flanders, 1759–1840)
Engraving and coloring by Victor
(French, active 1820–1850)
Platemark: 27.5 × 21.6 cm (10 ⁹⁄₁₆ × 8 ½ in.)
Fund in memory of Horatio Greenough Curtis 1970.19

80–81
Mrs. Edward Bury (English, 1799–1872)
A Selection of Hexandrian Plants
London: 1831–34
Illustrated with 51 aquatints, partially printed in color and finished by hand
Dunthorne 71, Nissen 306

80. *Small Striped Amaryllis (Amaryllis vittata minor)*, plate 40
Design by Mrs. Edward Bury
(English, 1799–1872)

Engraving and coloring by
Robert Havell, Jr. (American, born in England, 1793–1878)
Platemark: 42.2 × 24.5 cm (16 ⅝ × 9 ⅝ in.)
Bequest of George P. Dike – Elita R. Dike Collection 69.128

81. *Crinum Lily (Crinum scabrum)*, plate 32
Design by Mrs. Edward Bury
(English, 1799–1872)
Engraving and coloring by
Robert Havell, Jr. (American, born in England, 1793–1878)
Platemark: 43.5 × 43.2 cm (17 ⅛ × 17 in.)
Bequest of George P. Dike – Elita R. Dike Collection 69.130

82–84
Sir Joseph Paxton (English, 1803–1865)
The Magazine of Botany, and Register of Flowering Plants
London: 1834–1849
Illustrated with more than 700 hand-colored lithographs, etchings, engravings, and aquatints
Nissen 2351

82. *Wayman's Brugmansia (Brugmansia Waymaniana)*
Design possibly by Frederick William Smith (English, 1797–1835)
Aquatint, color printing, and coloring by unidentified artist
(English, 19th century)
Platemark: 21.5 × 14.5 cm (8 ⁷⁄₁₆ × 5 ¹¹⁄₁₆ in.)
Bequest of George P. Dike – Elita R. Dike Collection 69.331

83. *Exceptional Astelma (Astelma eximium)*
Design possibly by Frederick William Smith (English, 1797–1835)
Aquatint, color printing, and coloring by unidentified artist
(English, 19th century)
Sheet: 22.8 × 16.2 cm (9 × 6 ⅜ in.)
Bequest of George P. Dike – Elita R. Dike Collection 69.335

84. *Changing Camellia (Camellia mutabilis)*
Design possibly by Frederick William Smith (English, 1797–1835)
Aquatint, color printing, and coloring by unidentified artist
(English, 19th century)

Sheet: 22.8 × 15.8 cm (9 × 6 ¼ in.)
Bequest of George P. Dike – Elita R. Dike Collection 69.330

85–87
Abbé Laurent Berlèse (French, 1784–1863)
Iconographie du Genre Camellia, 3 vols.
Paris: 1839–43
Illustrated with 300 stipple and line engravings, partially printed in color and finished by hand
Dunthorne 30, Nissen 150

85. *Smith's Large-Flowered Camellia (Camellia Smithii Grandiflora)*, plate 127
Design by Johann Jakob Jung
(German, active 1819–1844)
Engraving by Oudet
(French, 19th century)
Platemark: 30 × 22.5 cm
(11 ¹³⁄₁₆ × 8 ⅞ in.)
Bequest of George P. Dike – Elita R. Dike Collection 69.221

86. *Apollo Camellia (Camellia Apollina)*, plate 164
Design by Johann Jakob Jung
(German, active 1819–1844)
Engraving by Oudet
(French, 19th century)
Platemark: 30 × 23 cm (11 ¹³⁄₁₆ × 9 ¹⁄₁₆ in.)
Bequest of George P. Dike – Elita R. Dike Collection 69.224

87. *Camellia japonica Imbricata Rubra*
Design by Johann Jakob Jung
(German, active 1819–1844)
Engraving by Gabriel
(French, 19th century)
Platemark: 30.5 × 23.5 cm (12 × 9 ¼ in.)
Bequest of George P. Dike – Elita R. Dike Collection 69.228

88–93
John Fisk Allen (American, 1807–1876)
Victoria Regia; or the Great Water Lily of America. With a Brief Account of Its Discovery and Introduction into Cultivation: With Illustrations by William Sharp from Specimens Grown at Salem, Massachusetts, U.S.A.
Boston: 1854
Illustrated with 6 chromolithographs
Nissen 16

88. *The First Two Cycles of the Growth of the Lily*, plate 1
Design and chromolithography by William Sharp (American, born in England, 1803–1875) after a sketch by John Fisk Allen (American, 1807–1876)
Image: 38.6 × 53.6 cm (15 3/16 × 21 1/8 in.)
Gift of Charles D. Childs 48.56a

89. *Opening Flower*, plate 2
Design and chromolithography by William Sharp (American, born in England, 1803–1875)
Image: 38.4 × 53.6 cm (15 1/8 × 21 1/8 in.)
Gift of Charles D. Childs 48.57

90. *Underside of the Leaf*, plate 3
Design and chromolithography by William Sharp (American, born in England, 1803–1875)
Sheet: 56 × 74 cm (22 1/16 × 29 1/8 in.)
Gift of Charles D. Childs 48.58

91. *Intermediate Stages of Bloom*, plate 4
Design and chromolithography by William Sharp (American, born in England, 1803–1875)
Image: 39.6 × 53.2 cm (15 9/16 × 20 15/16 in.)
Gift of Charles D. Childs 48.59

92. *Complete Bloom*, plate 5
Design and chromolithography by William Sharp (American, born in England, 1803–1875)
Image: 38.3 × 53.5 cm (15 1/16 × 21 1/8 in.)
Gift of Charles D. Childs 48.60

93. *A Partial Bloom Caused by Low Temperature*, plate 6
Design and chromolithography by William Sharp (American, born in England, 1803–1875)
Image: 38.2 × 53.5 cm (15 1/16 × 21 1/16 in.)
Gift of Charles D. Childs 48.61

Also in the Exhibition:

Jean Vauquer (French, 1621–1686)

Bouquet with Peonies, 17th century
Etching
Platemark: 36 × 27.8 cm (14 3/16 × 10 15/16 in.)
Maria Antoinette Evans fund
30.1340.2

Bouquet with Sunflowers (see fig. 2), 17th century
Etching
Sheet, trimmed within platemark: 35.3 × 27 cm (13 7/8 × 10 5/8 in.)
Maria Antoinette Evans fund
30.1340.11

A Society of Gardeners
Catalogus Plantarum
London: 1730
Illustrated with 21 engravings and mezzotints
Dunthorne 119, Nissen 2230

Long-Coned Cornish Fir, Balm of Gilead Fir, plate 2
Design by Jacobus van Huysum (Dutch, active in England, 1687/89–1740)
Mezzotint and etching by Elisha Kirkall (English, about 1682–1742)
Platemark: 38.1 × 25.4 cm (15 × 10 in.)
Bequest of George P. Dike – Elita R. Dike Collection 69.216

Jacobus van Eynden (Dutch, 1733–1824)

Tulips and Jonquils with Dragonfly and Ladybug, about 1760
Watercolor on paper
Sheet: 38.5 × 24.5 cm (15 1/8 × 9 5/8 in.)
Bequest of George P. Dike – Elita R. Dike Collection 69.366

John Edwards (English, active 1768–1806)
The British Herbal
London: 1770
Illustrated with 100 hand-colored etchings and engravings
Dunthorne 104, Nissen 578

The Scarlet Flowering Horse Chestnut (Pavia), plate 46
Design, etching, and engraving by John Edwards (English, active 1768–1806)
Platemark: 35 × 24.7 cm (13 3/4 × 9 3/4 in.)
Bequest of George P. Dike – Elita R. Dike Collection 69.143

Carmine Lily of Byzantium (Lilium Byzantium), plate 71
Design, etching, and engraving by John Edwards (English, active 1768–1806)
Platemark: 34.8 × 24.8 cm (13 11/16 × 9 3/4 in.)
Bequest of George P. Dike – Elita R. Dike Collection 69.147

Charles Melchior Descourtis (French, 1753–1820)
after Cornelis van Spaendonck (Dutch, active in France, 1756–1839)

Marigold and Poppy, 1780–90
Design by Cornelis van Spaendonck (Dutch, active in France, 1756–1839)
Mezzotint, engraving, and hand-coloring by Charles Melchior Descourtis (French, 1753–1820)
Platemark: 28.8 × 21 cm (11 5/16 × 8 1/4 in.)
Maria Antoinette Evans Fund 30.1208

Louis-Marin Bonnet (French, 1736–1793) and Louis Joseph Mondhare (French, active 1759–1792)
Premier [Dixième] Cahier de Fleurs, Cahier de Bouquets de Fleurs, Cahier de Fruits
Paris: about 1773–84
Illustrated with 46 crayon-manner engravings

Designs by Henri Sallembier (French, about 1753–1820) and Carle (French, 18th century)
Engravings by Louis-Marin Bonnet (French, 1736–1793) and Roubillac (French, 1739–about 1820)
Book, overall: 30.2 × 24.1 × 2.2 cm (11 7/8 × 9 1/2 × 7/8 in.)
Maria Antoinette Evans Fund 30.1329

Mary Lawrance
(English, active 1790–1831)
A Collection of Roses from Nature
London: 1799
Illustrated with 90 hand-colored etchings,
soft-ground etchings, and stipple
engravings
Dunthorne 176, Nissen 1151

Marbled Rose, plate 57, 1797
Design, engraving, and coloring by
Mary Lawrance
(English, active 1790–1831)
Platemark: 33 × 28 cm (13 × 11 in.)
Bequest of George P. Dike – Elita R.
Dike Collection 69.238

Great Royal Rose, plate 58, 1798
Design, engraving, and coloring by
Mary Lawrance
(English, active 1790–1831)
Platemark: 32.8 × 27.8 cm
(12 ¹⁵⁄₁₆ × 10 ¹⁵⁄₁₆ in.)
Bequest of George P. Dike – Elita R.
Dike Collection 69.239

Henry Charles Andrews
(English, active 1794–1830)
Coloured Engravings of Heaths
London: 1802–30
Illustrated with 288 hand-colored
etchings
Dunthorne 9

Spiky Heather (Erica Spicata), 1795
Design by unidentified artist
(English, 18th century)
Etching and coloring by unidentified
artist (English, 18th century)
Platemark: 27 × 17.5 cm (10 ⅝ × 6 ⅞ in.)
Bequest of George P. Dike – Elita R.
Dike Collection 69.85

Sydenham Edwards (English, 1768–1819)
***A Complete Dictionary of Practical
Gardening, by Alexander MacDonald,
Gardener, in Two Volumes***
London: 1807
Illustrated with 61 hand-colored
engravings, with figures of 133 plants
Dunthorne 106

*Cobweb Houseleek (Sempervivum
Arachnoideum)*, 2. *Stemless Strelitzia
(Strelitzia Reginae)*, plate 53
Design by Sydenham Edwards
(English, 1768–1819)
Engraving and coloring by Francis
Sansom (English, active 1788–1810s)
Platemark: 28.1 × 22.5 cm (11 ¹⁄₁₆ × 8 ⅞ in.)
Bequest of George P. Dike – Elita R.
Dike Collection 69.180

Valentine Bartholomew
(English, 1799–1879)
***A Selection of Flowers, Adapted Principally
for Students, Drawn on Stone by V.
Bartholomew***
London: 1822
Illustrated with 24 hand-colored
lithographs
Dunthorne 22, Nissen 82

Tulip
Design and lithography by Valentine
Bartholomew (English, 1799–1879)
Sheet: 36.2 × 26 cm (14 ¼ × 10 ¼ in.)
Bequest of George P. Dike – Elita R.
Dike Collection 69.116

Anonymous
***Ten Lithographic Coloured Flowers with
Botanical Descriptions. Drawn and
Coloured by A Lady***
Edinburgh: 1826
Illustrated with 40 hand-colored
lithographs
Dunthorne 19

Soft Achania (Achania Mollis), plate 12
Design by unidentified artist
(British, 19th century)
Lithography and coloring by R. H.
Nimmo (Scottish, 19th century)
Sheet: 36 × 25.3 cm (14 ³⁄₁₆ × 9 ¹⁵⁄₁₆ in.)
Bequest of George P. Dike – Elita R.
Dike Collection 69.113

Margaret Roscoe
(English, active 1829–1838)
Floral Illustrations of the Seasons
London: 1829
Illustrated with 55 hand-colored
aquatints and engravings
Dunthorne 266, Nissen 1676

Fern-Leaved Peony (Paeonia Tenuifolia),
plate 17, 1829
Design by Margaret Roscoe
(English, active 1829–1838)
Aquatint, engraving, and coloring by
Robert Havell, Jr. (American, born in
England, 1793–1873)
Platemark: 25.2 × 19 cm (9 ¹⁵⁄₁₆ × 7 ½ in.)
Bequest of George P. Dike – Elita R.
Dike Collection 69.319

James Andrews (English, 1801–1876)
***Flora's Gems; or The Treasures of the
Parterre***
London: n.d. [about 1835]
Illustrated with 12 hand-colored
lithographs
Dunthorne 13, Nissen 35

Three Chrysanthemums
Design, lithography, and coloring by
James Andrews
(English, active 1801–1876)
Sheet: 36 × 26.5 cm (14 ³⁄₁₆ × 10 ⁷⁄₁₆ in.)
Bequest of George P. Dike – Elita R.
Dike Collection 69.95

Robert Wight (English, 1796–1872)
***Icones Plantarum Indiae Orientalis; or
Figures of Indian Plants***, 6 vols.
Madras and London: 1838–53
Illustrated with 2115 hand-colored
lithographs
Nissen: 2139

*Palm-Leaved Trichosanthes
(Cucurbitacae: Trichosanthes Palmata)*
Design by Rungiah
(Indian, 19th century)
Lithography and coloring by G.
Winchester (British, 19th century)
Sheet: 28.2 × 22.2 cm (11 ⅛ × 8 ¾ in.)
Bequest of George P. Dike – Elita R.
Dike Collection 69.321

Robert Furber (English, about 1674–1756)
Twelve Months of Flowers
London: 1730
Illustrated with 13 hand-colored
engravings
Dunthorne 113, Nissen 674

Flower Chart for February
Design by Peter Casteels
(Flemish, active in England, 1684–1749)
Engraving and coloring by Henry
Fletcher (English, active 1715–1744)
Platemark: 40.5 × 30.2 cm
(15 $^{15}/_{16}$ × 11 $^{7}/_{8}$ in.)
Bequest of George P. Dike – Elita R.
Dike Collection 69.131

Flower Chart for April (see fig. 4)
Design by Peter Casteels
(Flemish, active in England, 1684–1749)
Engraving and coloring by Henry
Fletcher (English, active 1715–1744)
Platemark: 42 × 32 cm (16 $^{9}/_{16}$ × 12 $^{5}/_{8}$ in.)
Bequest of George P. Dike – Elita R.
Dike Collection 69.132

Pierre-Joseph Redouté
(French, born in Flanders, 1759–1840)
Traité des Arbres et Arbustes, 7 vols.
Paris: 1801–19
Illustrated with 494 stipple engravings,
printed in color and finished by hand
Dunthorne 243; Nissen 549

Trumpet Vine (Tecoma radicans),
t. 2, no. 3
Design by Pierre-Joseph Redouté
(French, born in Flanders, 1759–1840)
Engraving and coloring by Jean Marie
Mixelle, *ainé* (French, active 1800)
Platemark: 33.3 × 24 cm (13 $^{1}/_{8}$ × 9 $^{7}/_{16}$ in.)
Bequest of George P. Dike – Elita R.
Dike Collection 69.295

French Rose (Rosa Gallica), t. 7, no. 8
Design by Pancrace Bessa
(French, 1772–about 1835)
Engraving and coloring by Dubreuil
(active 1800–1820)
Platemark: 30.5 × 22.5 cm (12 × 8 $^{7}/_{8}$ in.)
Bequest of George P. Dike – Elita R.
Dike Collection 69.297

Suggested Readings

Barker, Nicolas. *Hortus Eystettensis: The Bishop's Garden and Besler's Magnificent Book*. New York: H. N. Abrams, 1994.

Blunt, Wilfrid, and William T. Stearn. *The Art of Botanical Illustration*. Revised and enlarged edition. Woodbridge, Suffolk, England: Antique Collectors' Club, in association with the Royal Botanic Gardens, Kew, 1994.

Blunt, Wilfrid, with the assistance of William T. Stearn. *The Compleat Naturalist: A Life of Linnaeus*. New York: The Viking Press, 1971.

Bridson, Gavin D. R., and Donald E. Wendel, with the assistance of James J. White. *Printmaking in the Service of Botany*. Pittsburgh: Hunt Institute for Botanical Documentation, Carnegie Mellon University, 1986.

Brindle, John V., and James J. White, with the assistance of Donald E. Wendel. *Flora Portrayed: Classics of Botanical Art from the Hunt Institute Collection*. Pittsburgh: Hunt Institute for Botanical Documentation, 1985.

Calmann, Gerta. *Ehret: Flower Painter Extraordinary*. Boston: New York Graphic Society, 1977.

Carnegie Institute. *Botanical Books, Prints, and Drawings from the Collection of Mrs. Roy Arthur Hunt*. Pittsburgh: Carnegie Institute, 1952.

Desmond, Ray. *A Celebration of Flowers: Two Hundred Years of Curtis's Botanical Magazine*. Kew, England: The Royal Botanic Gardens, Kew, in association with Collingridge, 1987.

Dunthorne, Gordon. *Flower and Fruit Prints of the 18th and Early 19th Centuries*. 1938; New York: Da Capo Press, 1970.

Gascoigne, Bamber. *Milestones in Color Printing, 1457–1859*. Cambridge: Cambridge University Press, 1997.

Getscher, Robert. *A Garden of Prints: An Exhibition of 18th and 19th Century Botanical Illustrations*. Cleveland: The Department of Fine Arts, John Carroll University, and Vixseboxse Galleries, 1980.

Griffiths, Antony. *Prints and Printmaking: An Introduction to the History and Techniques*. London: British Museum Publications, 1980.

Henrey, Blanche. *British Botanical and Horticultural Literature before 1800*. London and New York: Oxford University Press, 1975.

Hunt Botanical Library, compiled by Jane Quinby. *Catalogue of Botanical Books in the Collection of Rachel McMasters Miller Hunt*. Pittsburgh: Hunt Botanical Library, 1958.

Mallary, Peter, and Frances Mallary. *A Redouté Treasury*. New York: Vendome Press, 1986.

New York Botanical Garden. *Verdant Riches Revealed: A Selection from the Treasures of the LuEsther T. Mertz Library at the New York Botanical Garden*. New York: New York Botanical Garden and the Grolier Club of New York, 1998.

Nissen, Claus. *Die Botanische Buchillustration: Ihre Geschichte und Bibliographie*. 2 vols. Stuttgart: Hiersemann, 1951.

Reitsma, Ella, assisted by Sandrine Ulenberg. *Maria Sibylla Merian and Daughters: Women of Art and Science*. Translated by Lynne Richards. Amsterdam: Rembrandt House Museum, 2008.

Sitwell, Sacheverell. *Great Flower Books, 1700–1900*. New York: The Atlantic Monthly Press, 1990.

Stearn, William T. *Flower Artists of Kew*. London: Herbert Press, in association with the Royal Botanic Gardens, Kew. 1990.

Stearn, William T., and Martyn Rix. *Redouté's Fairest Flowers*. London: Herbert Press, in association with the Natural History Museum, 1987.

Tongiorgi Tomasi, Lucia. *An Oak Spring Flora*. Upperville, VA: Oak Spring Garden Library, 1997.